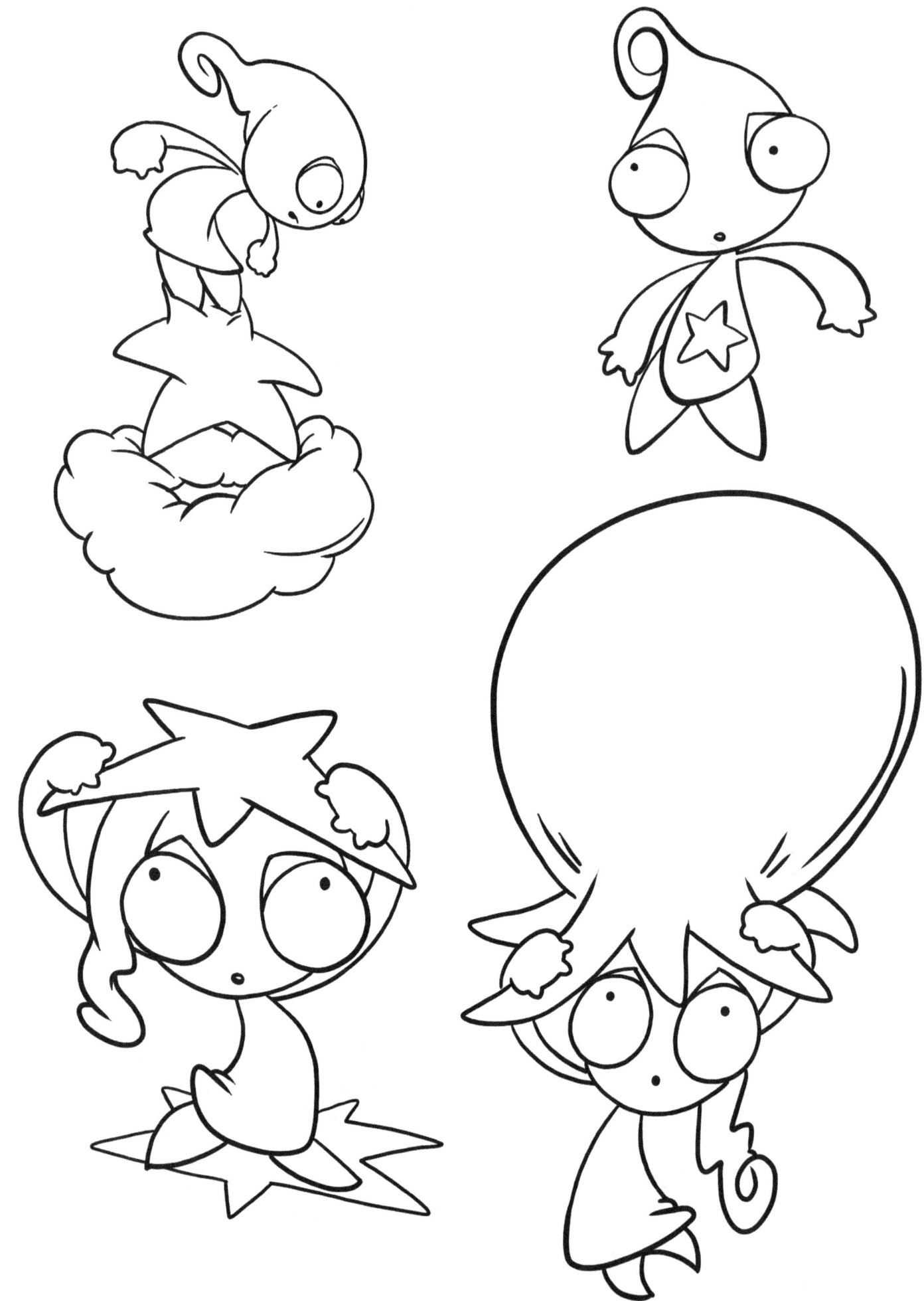

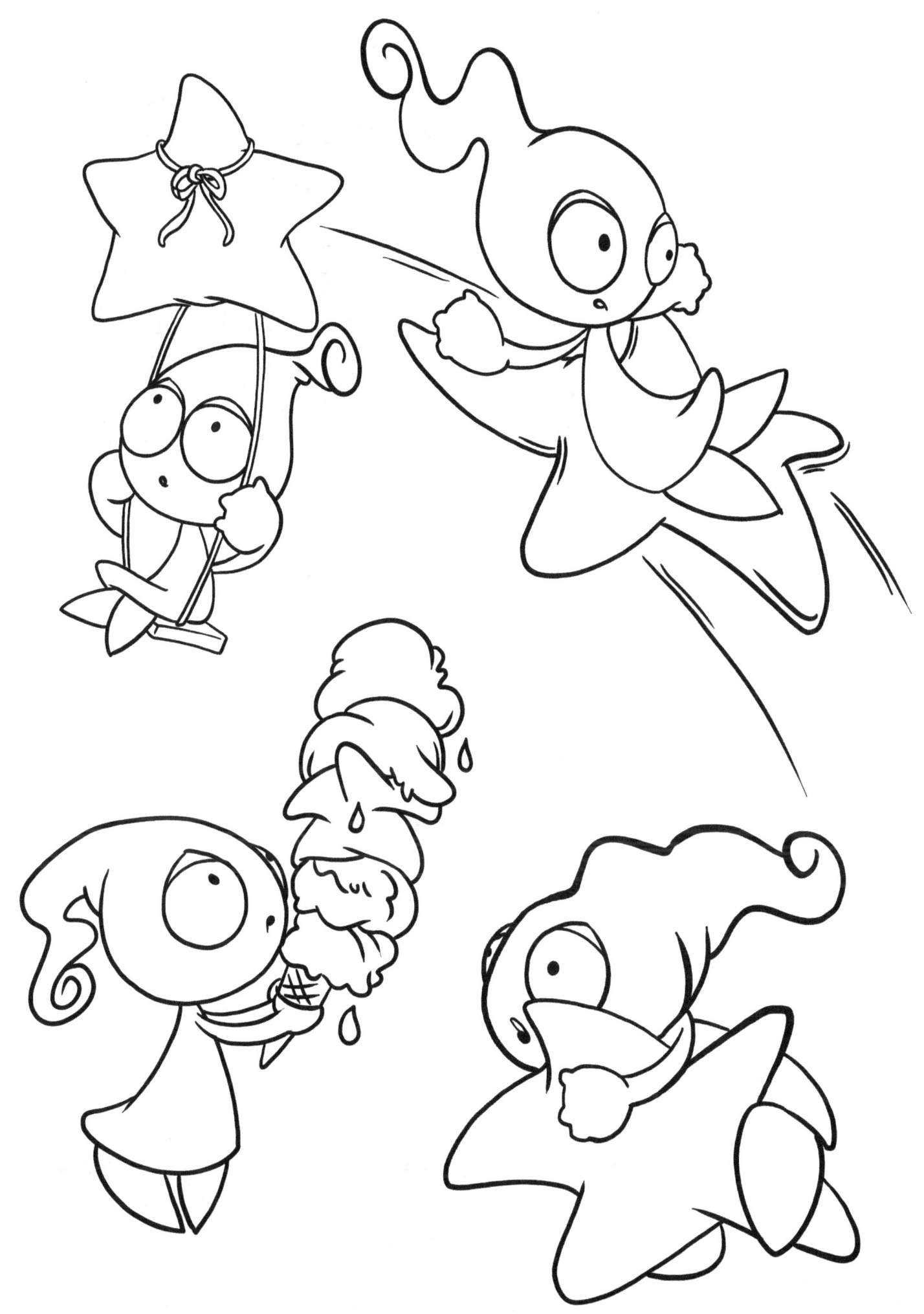

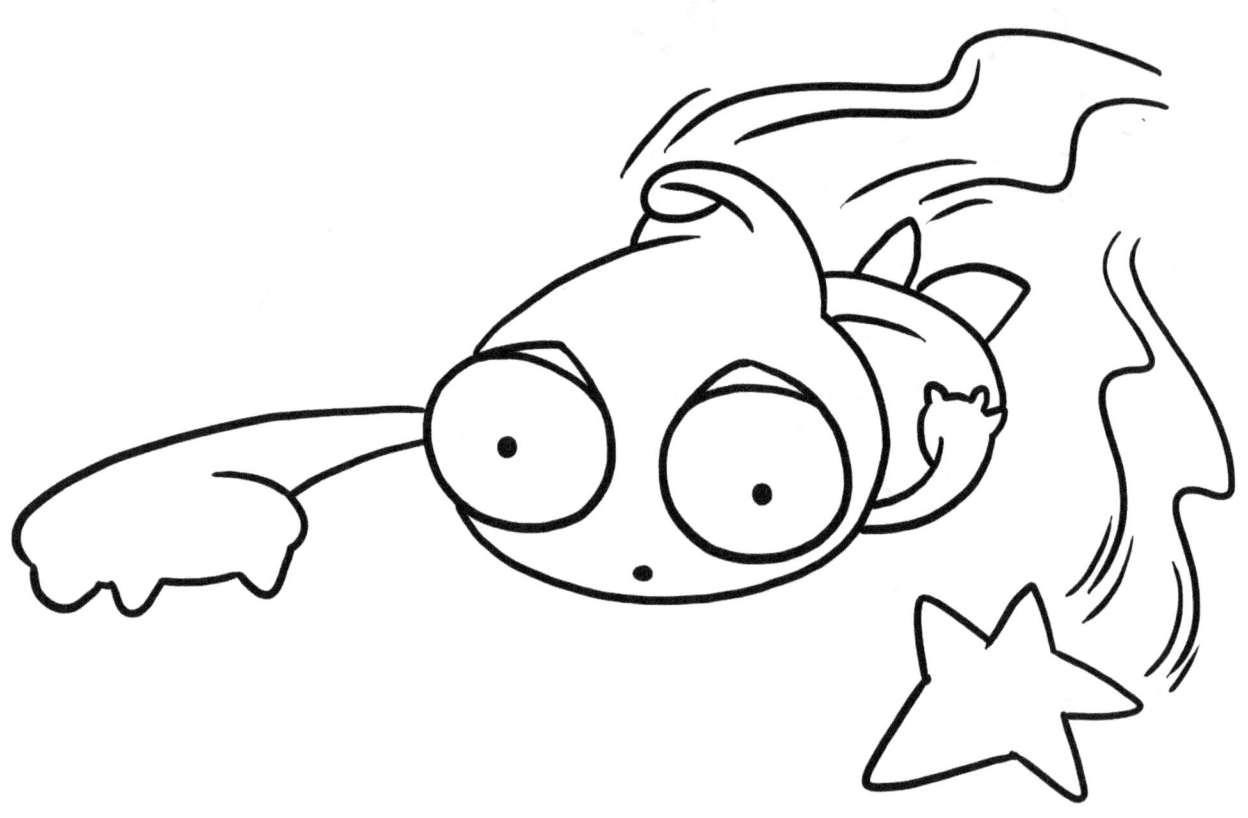

Written and illustrated by
L. Lane

...A Walk Through The Stars! - An Al and Mira Adventure!
© 2015 Do-Do Prints (a BMS division).

Do-Do Prints
do-do@bemystudio.com

All artwork and characters TM © 2015 Blue Monkey Studio.
Font used for text Vitamin and Vitamin Regular and Regular Outlined created by Jakob Fischer (www.pizzadude.dk). Commercial-use allowed.

No part of this book may be used or reproduced in any manner whatsoever without written permission except in the case of brief quotations embodied in critical articles and reviews.

ISBN: 978-1-326-45016-8

...A WALK THROUGH THE STARS!

AN AL AND MIRA ADVENTURE!

AL AND MIRA

AL IS A TAYLEN FROM THE PLANET TAYL.

TAYLENS AIM AT CONQUERING THEIR OWN HAPPINESS IN ORDER TO SPREAD IT THROUGH THE GALAXY.

THEIR SKIN IS USUALLY GREEN, ORANGE OR LIGHT BLUE, HOWEVER THEY CAN BE OF ANY COLOR.

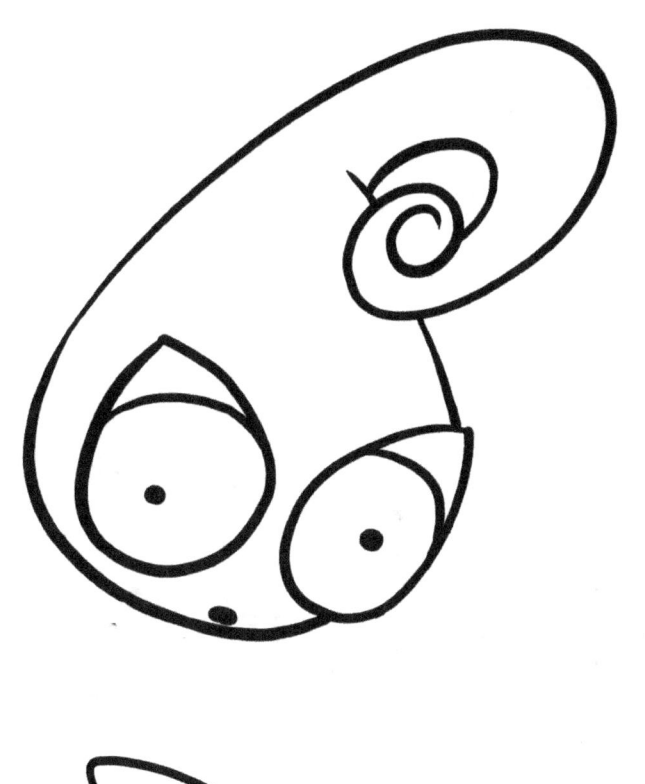

Their most peculiar feature is the their prenensile head-tail they use to express their emotions.

MIRA is an astryd, a wandering starbird.

Astryds travel through space looking for other good-hearted creatures to bond with.

They can withstand the rigors of deep space surviving for long period without air, water or food.

Astryds do not speak, however they share their emotions through empathy.

They can be of many different colors.

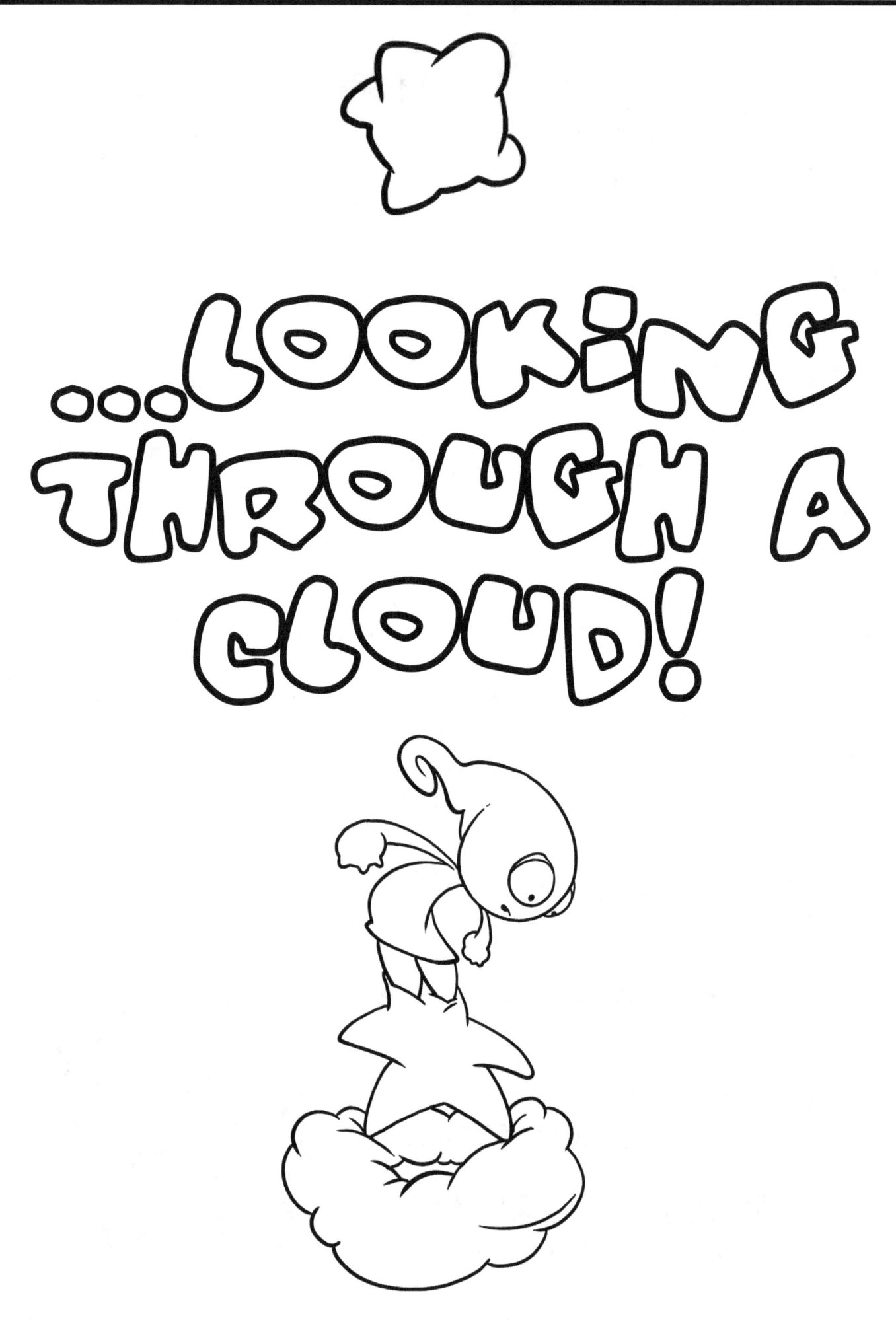

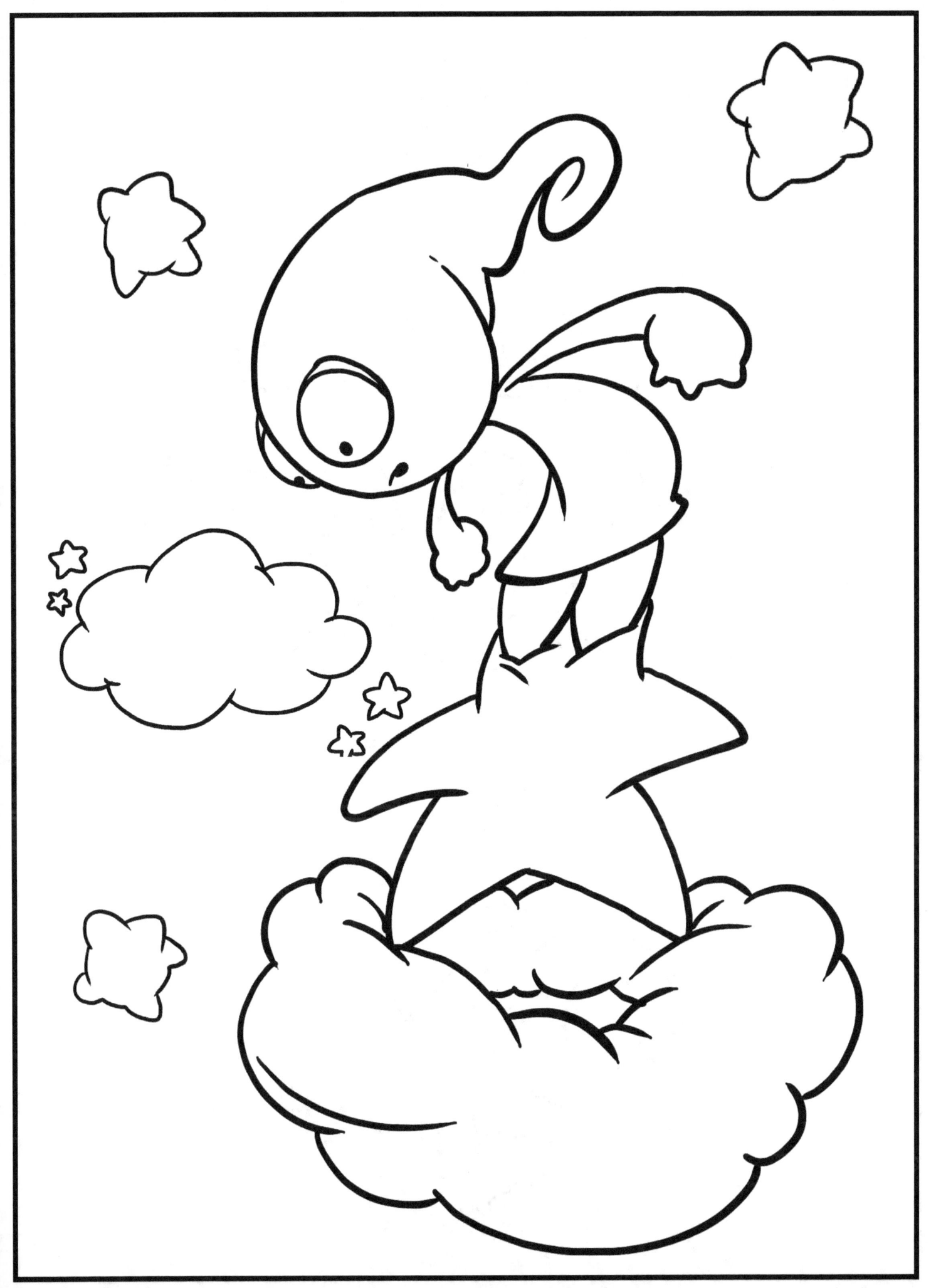

...FLYING WITH STARRY WINGS!

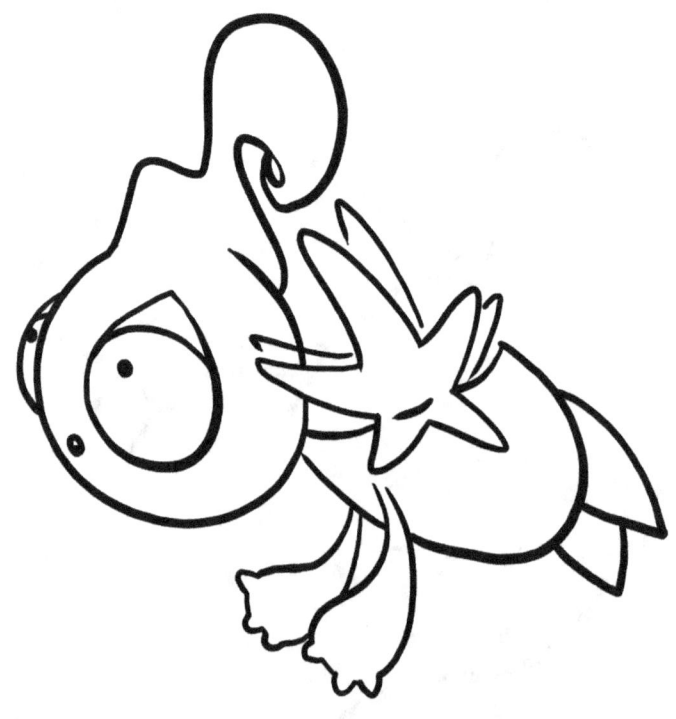

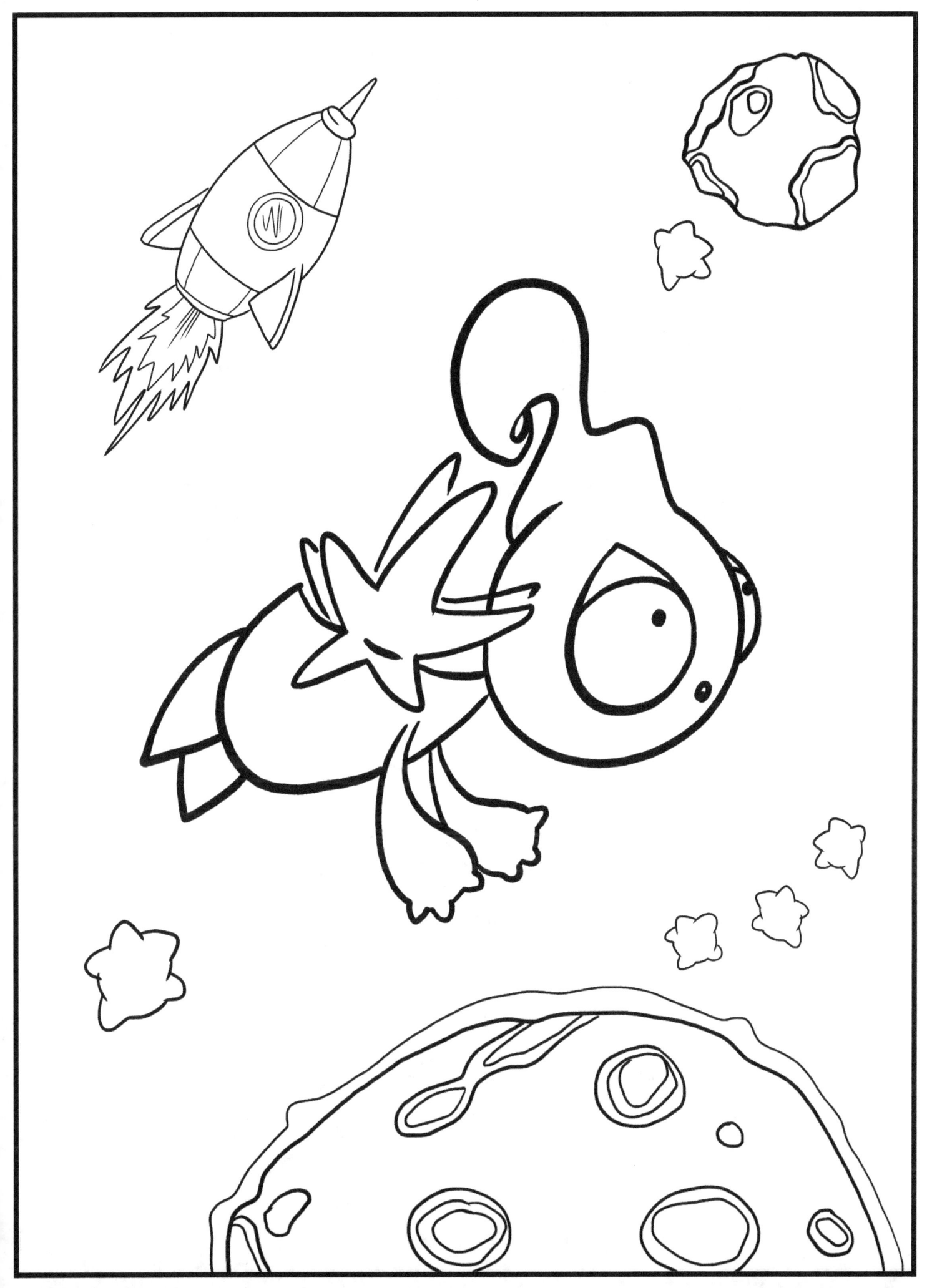

...EXPLORING PLANETS AFAR!

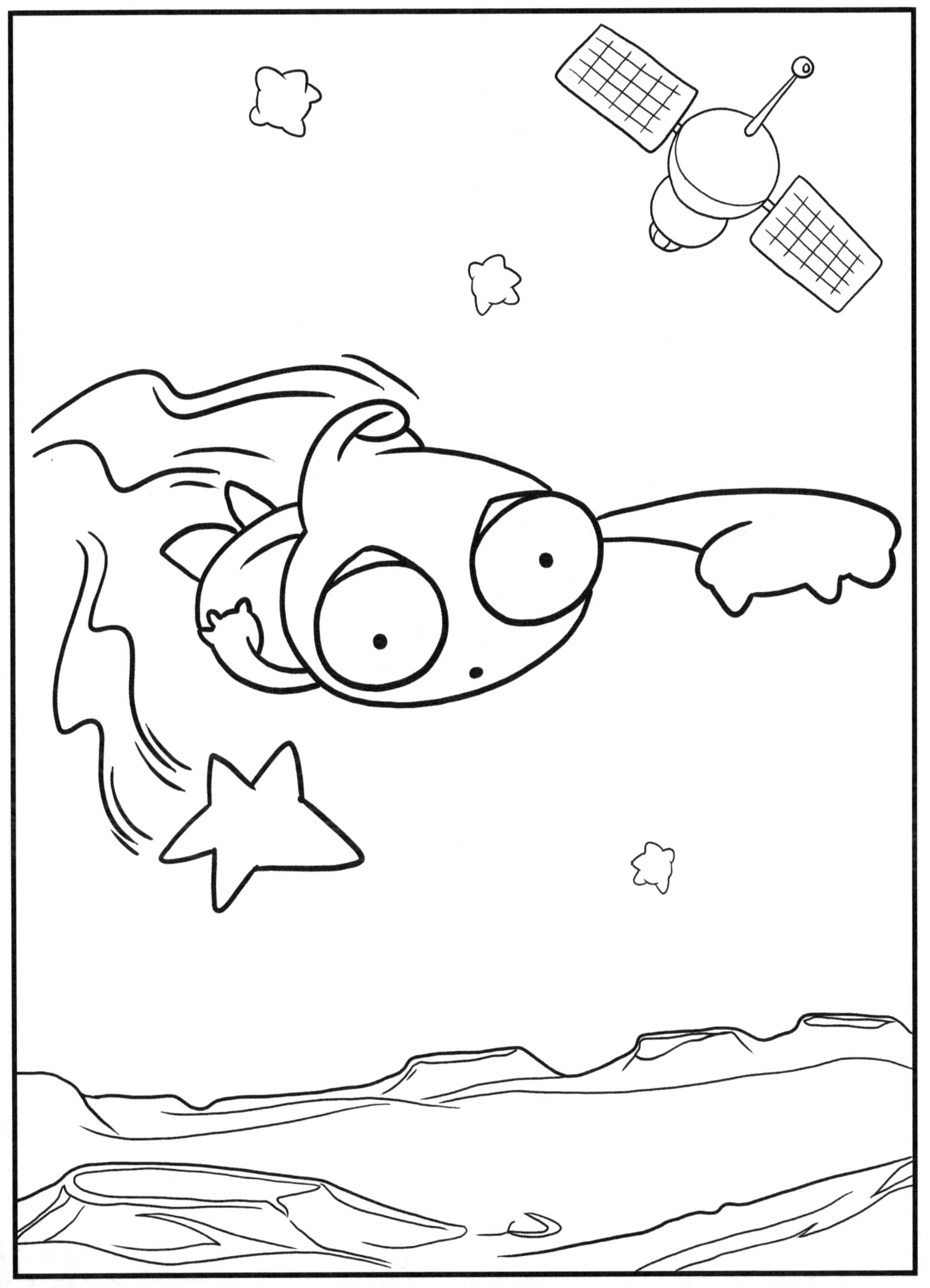

...SWINGING IN THE NIGHT SKY!

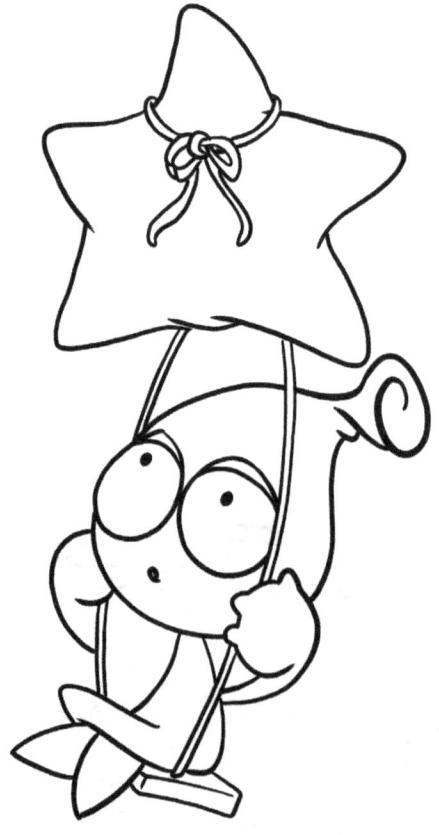

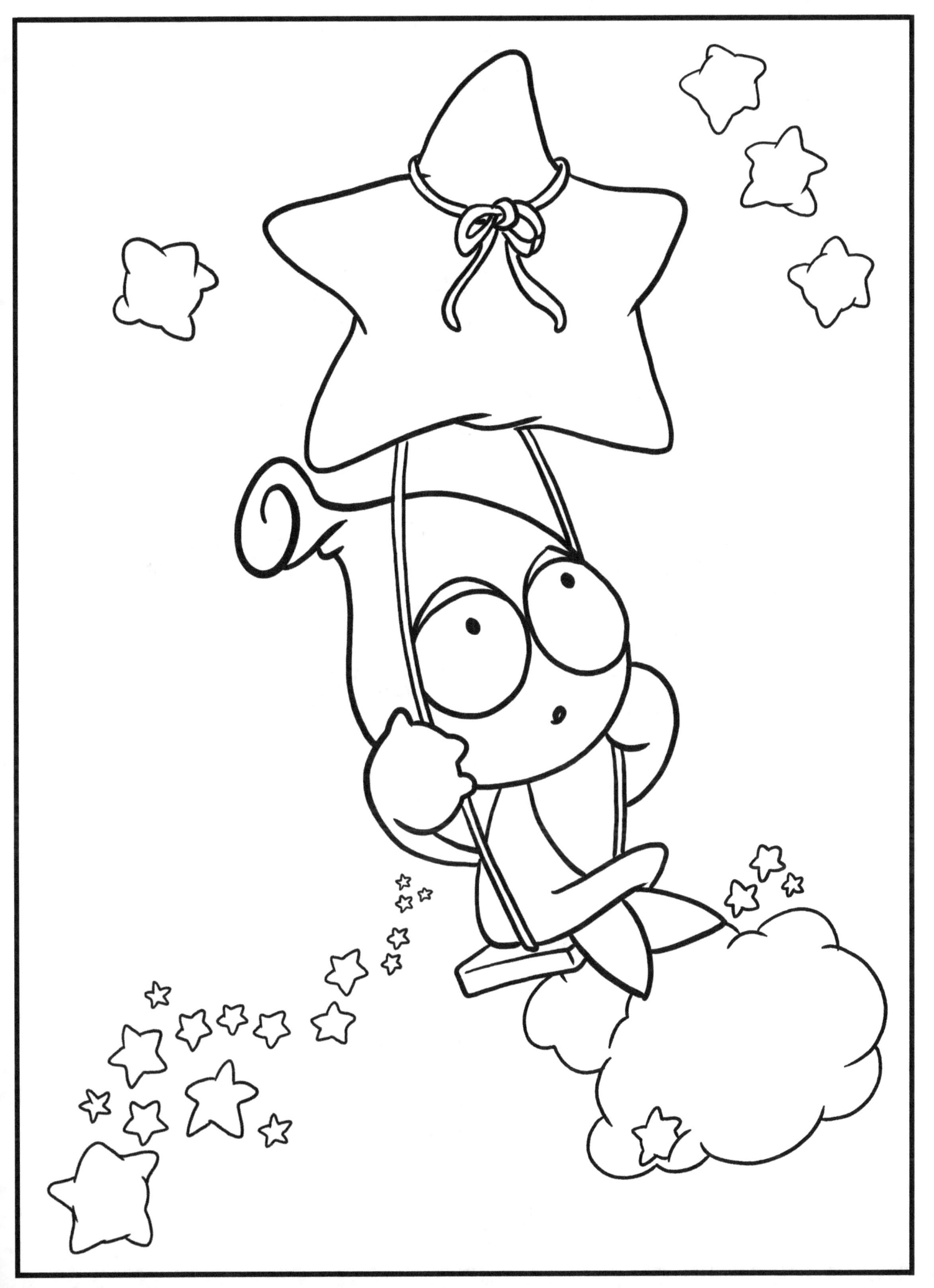

...BASE-JUMPING THROUGH THE STARS!

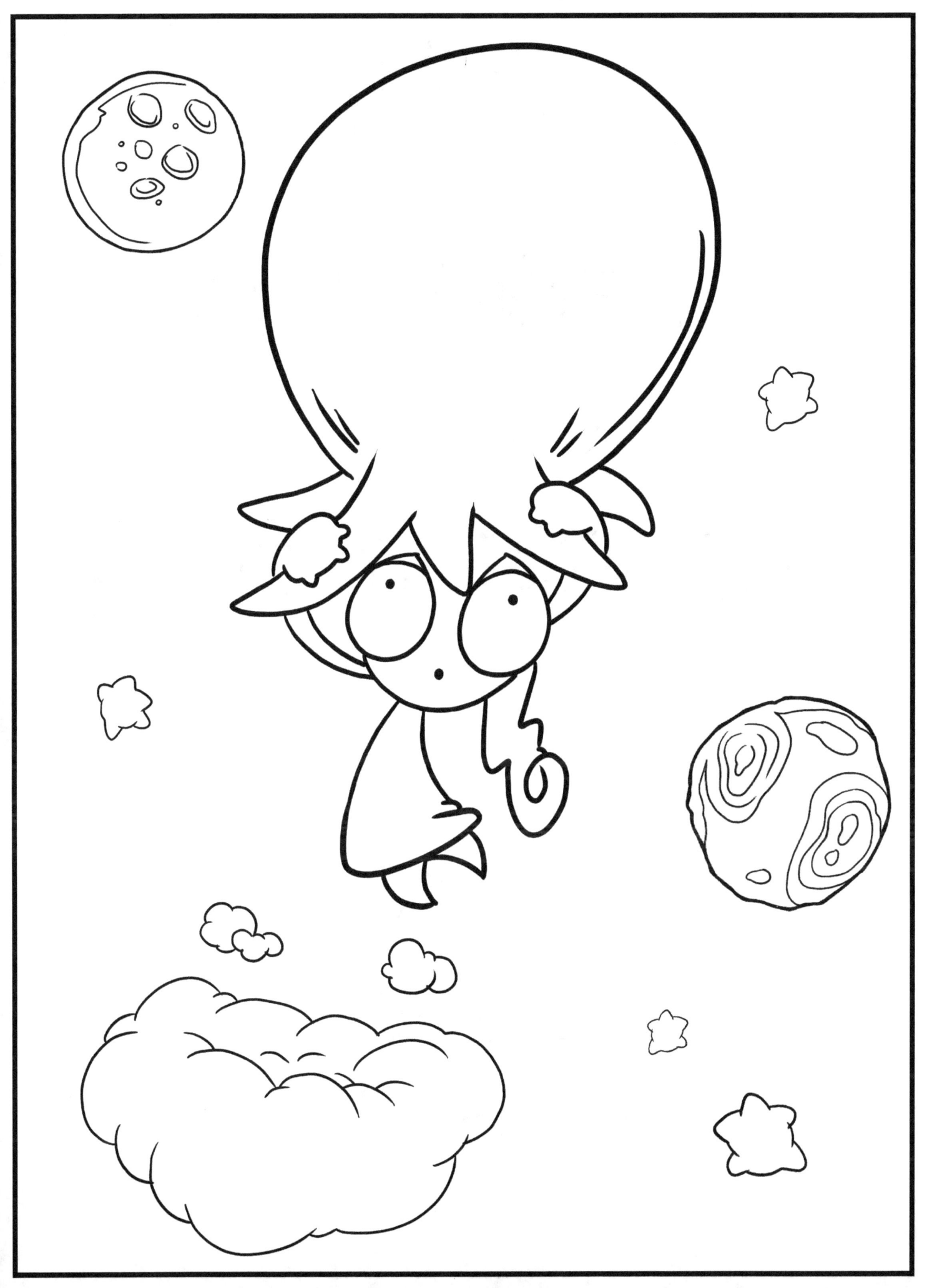

...resting after a stardust flu!

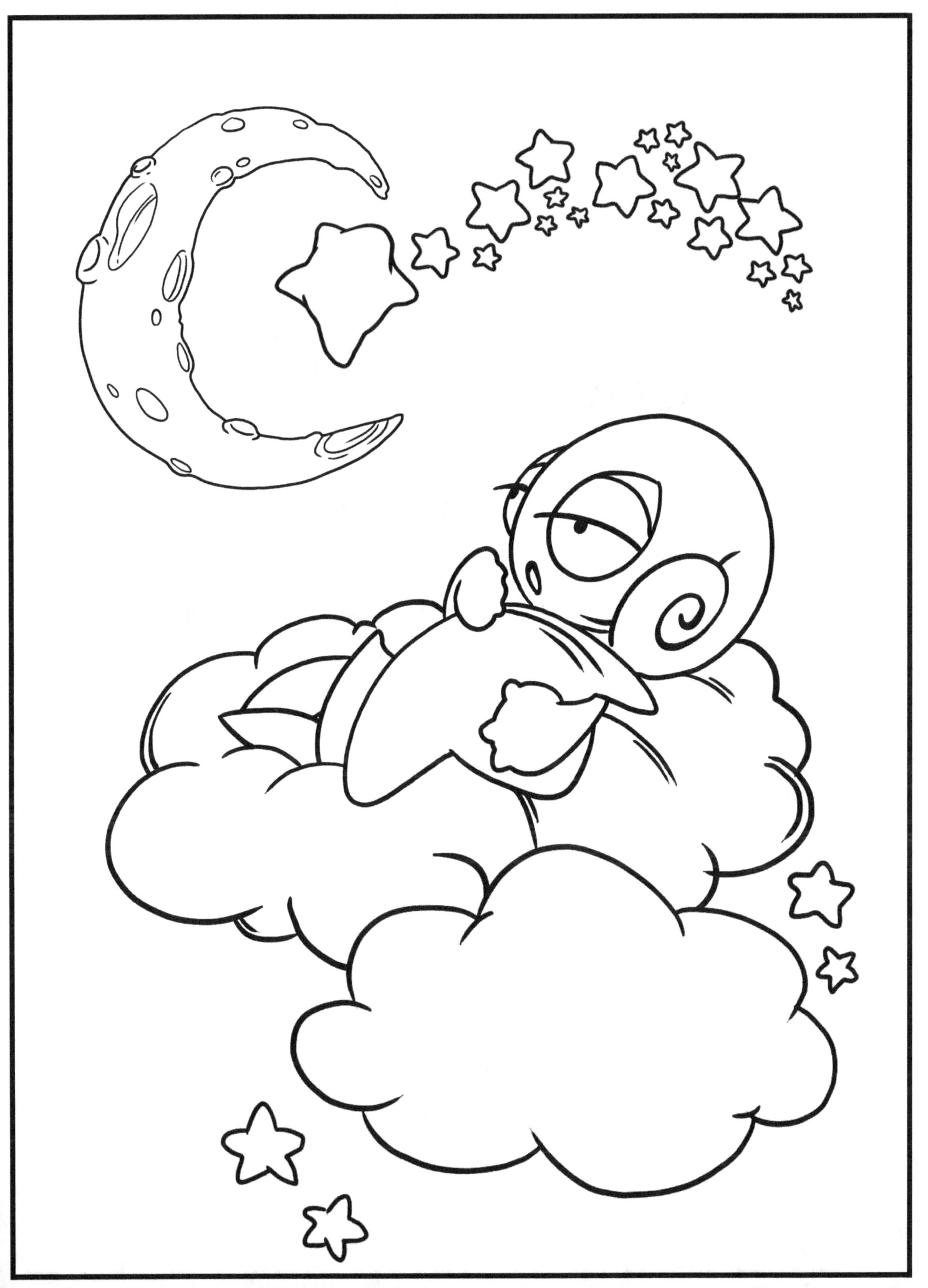

...Going for a space hike!

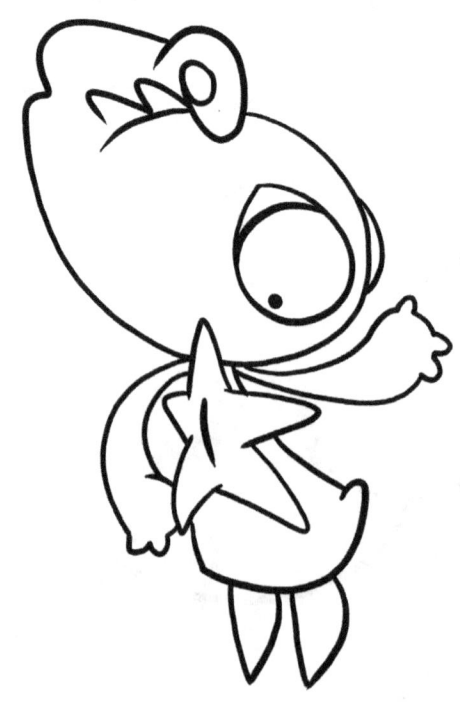

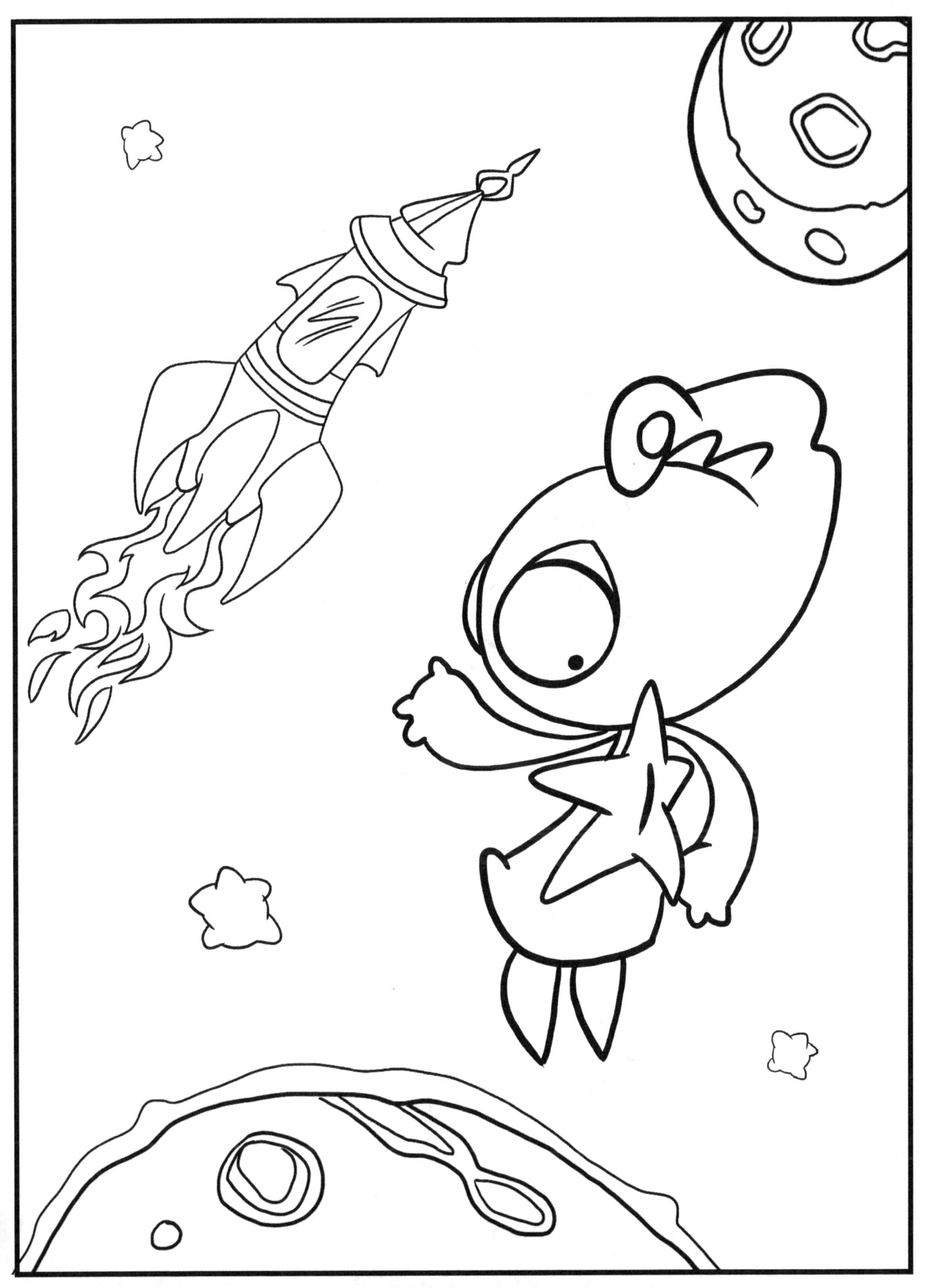

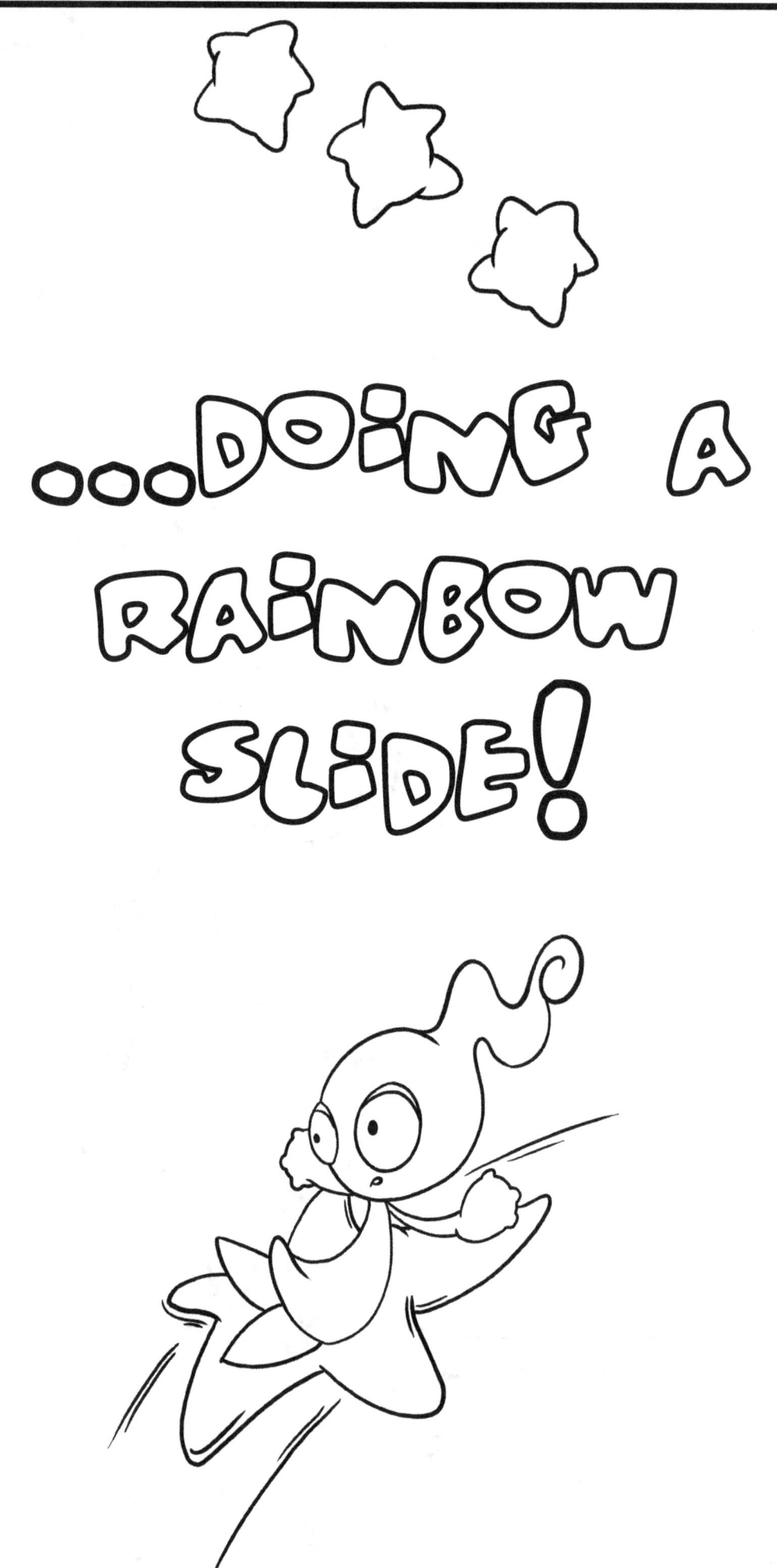

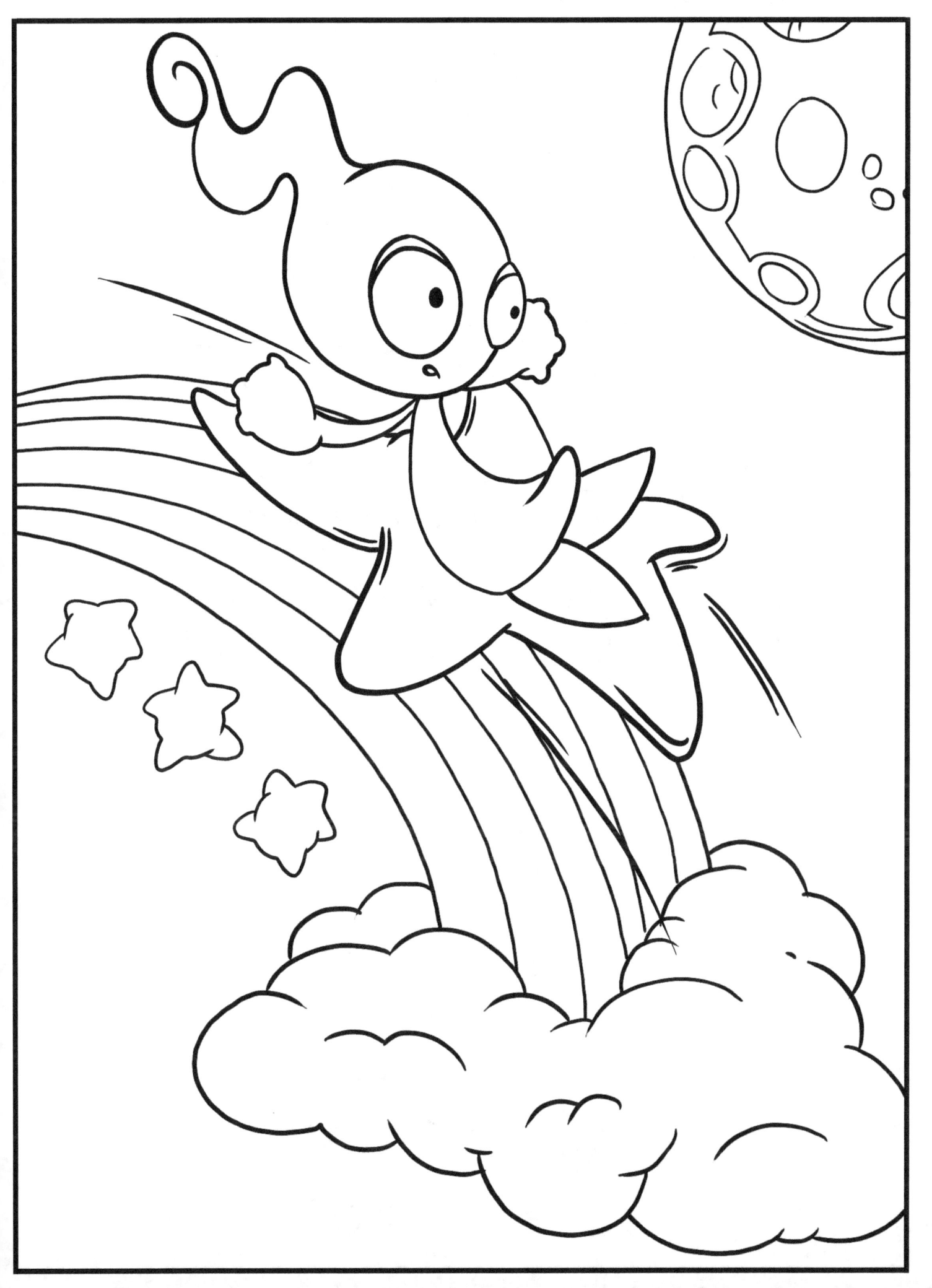

...SLIPPING WHILE PLAYING WITH MIRA!

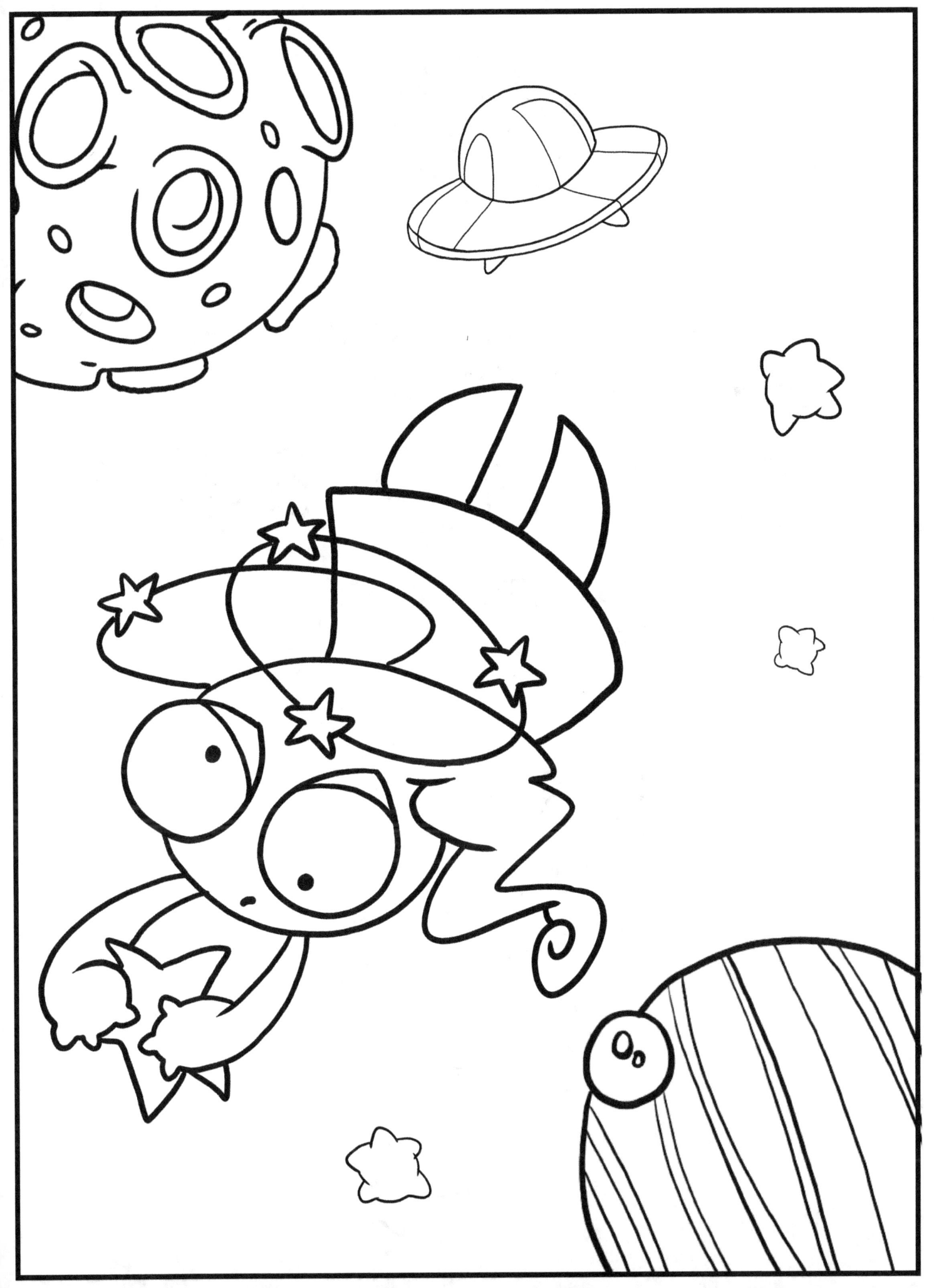

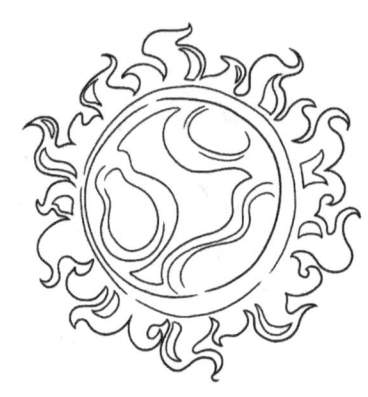

....TRYING TO SAVE THE ICE-CREAM!

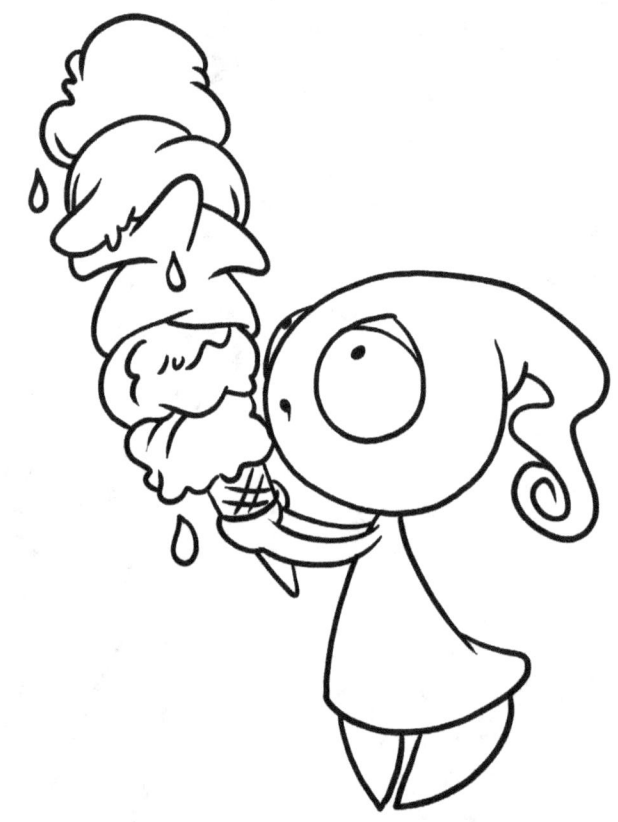

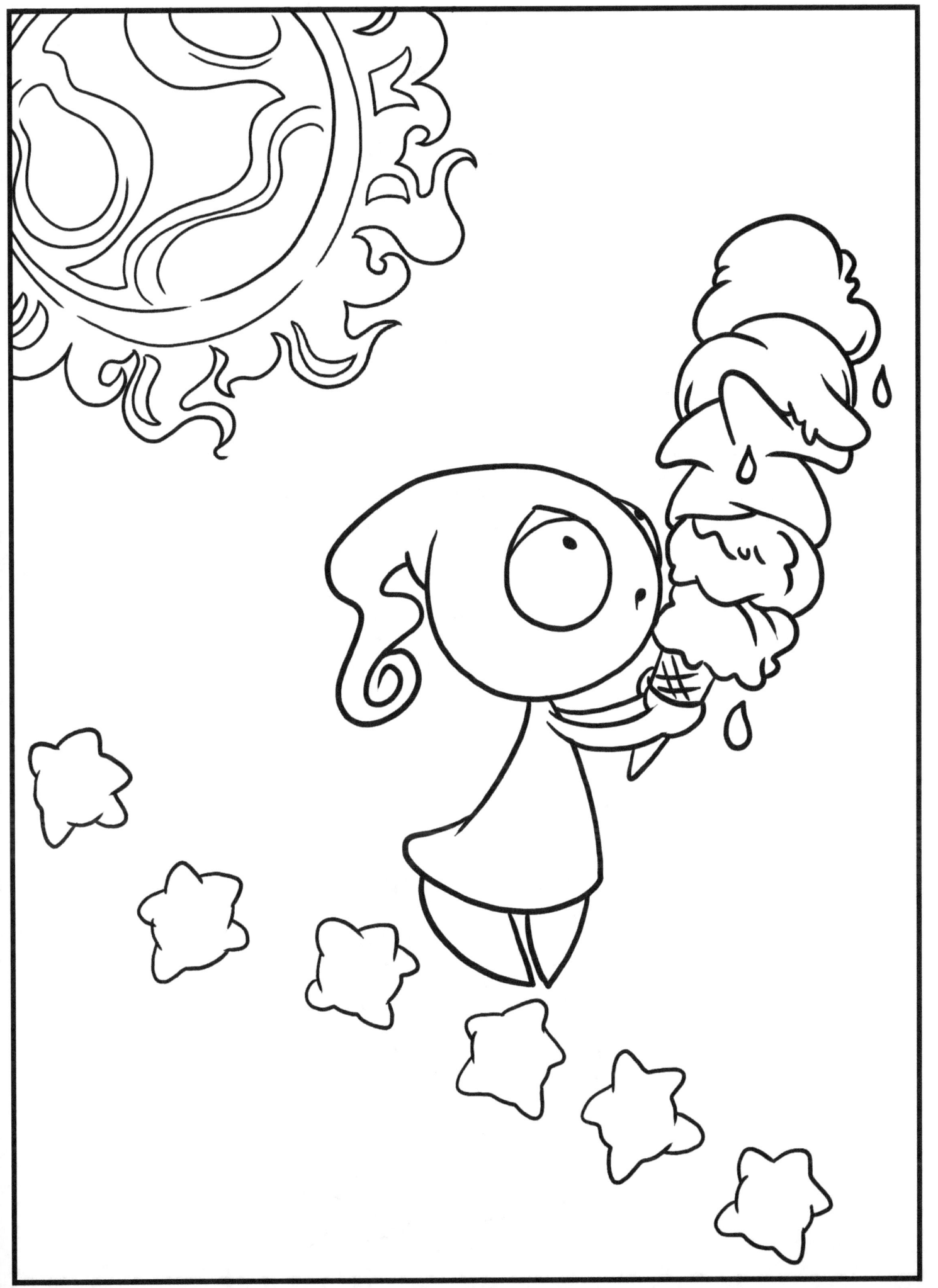

...SEEKING SHELTER FROM RAIN!

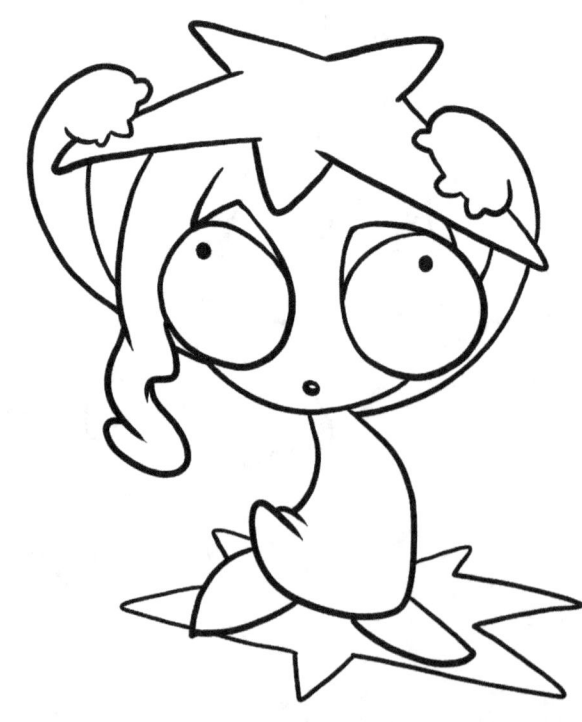

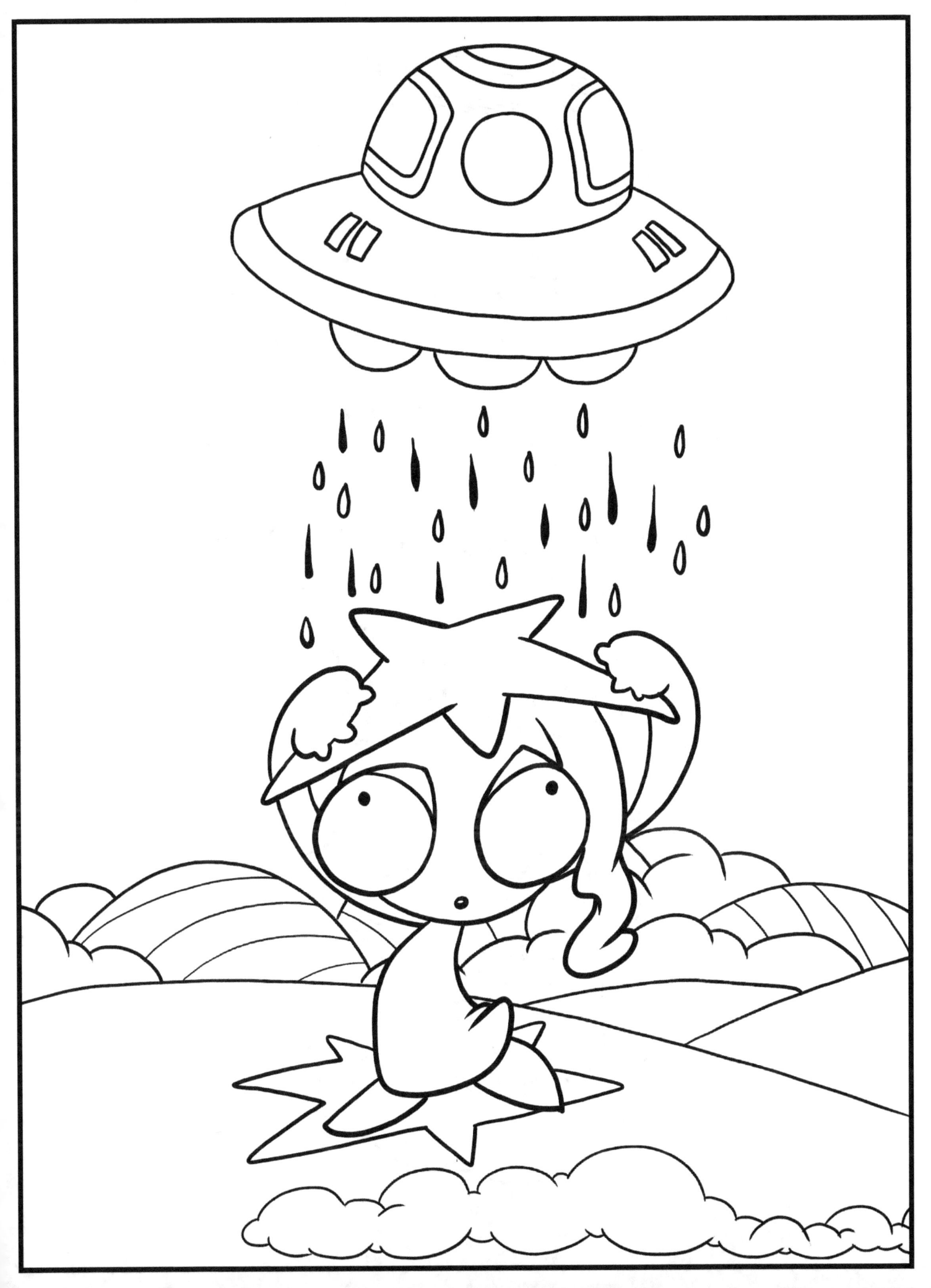

...TEASING MIRA, WHILE TAKING IT EASY!

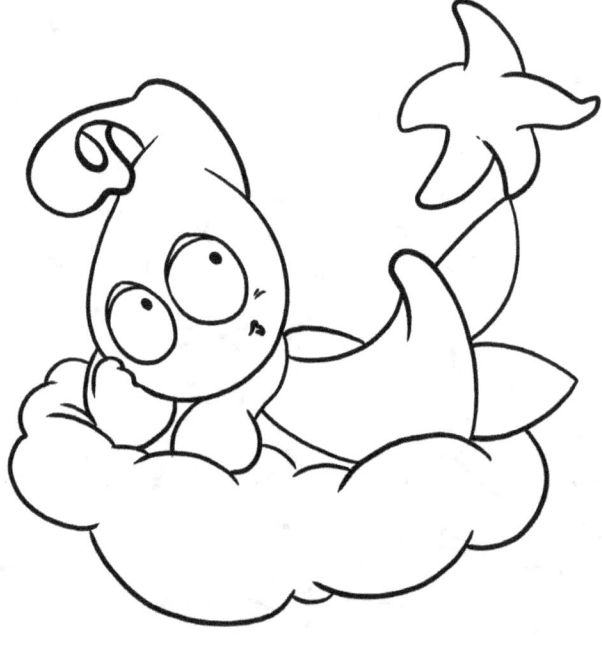

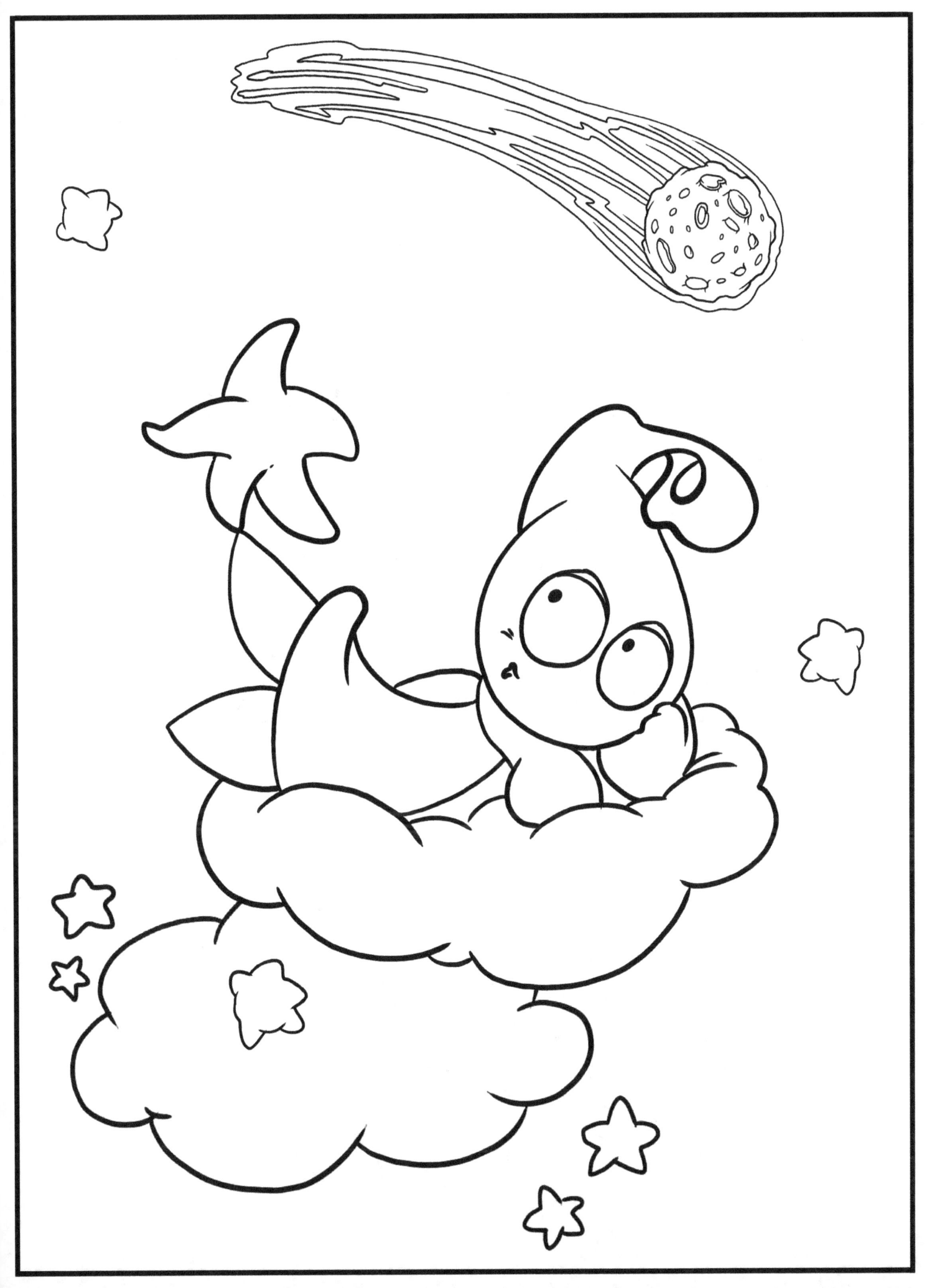

...DREAMING DEAREST FRIENDS!

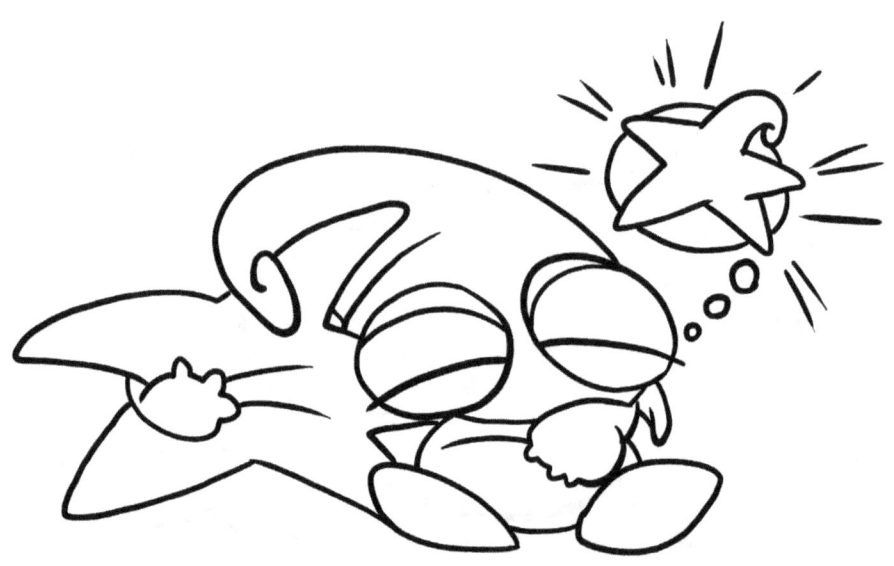

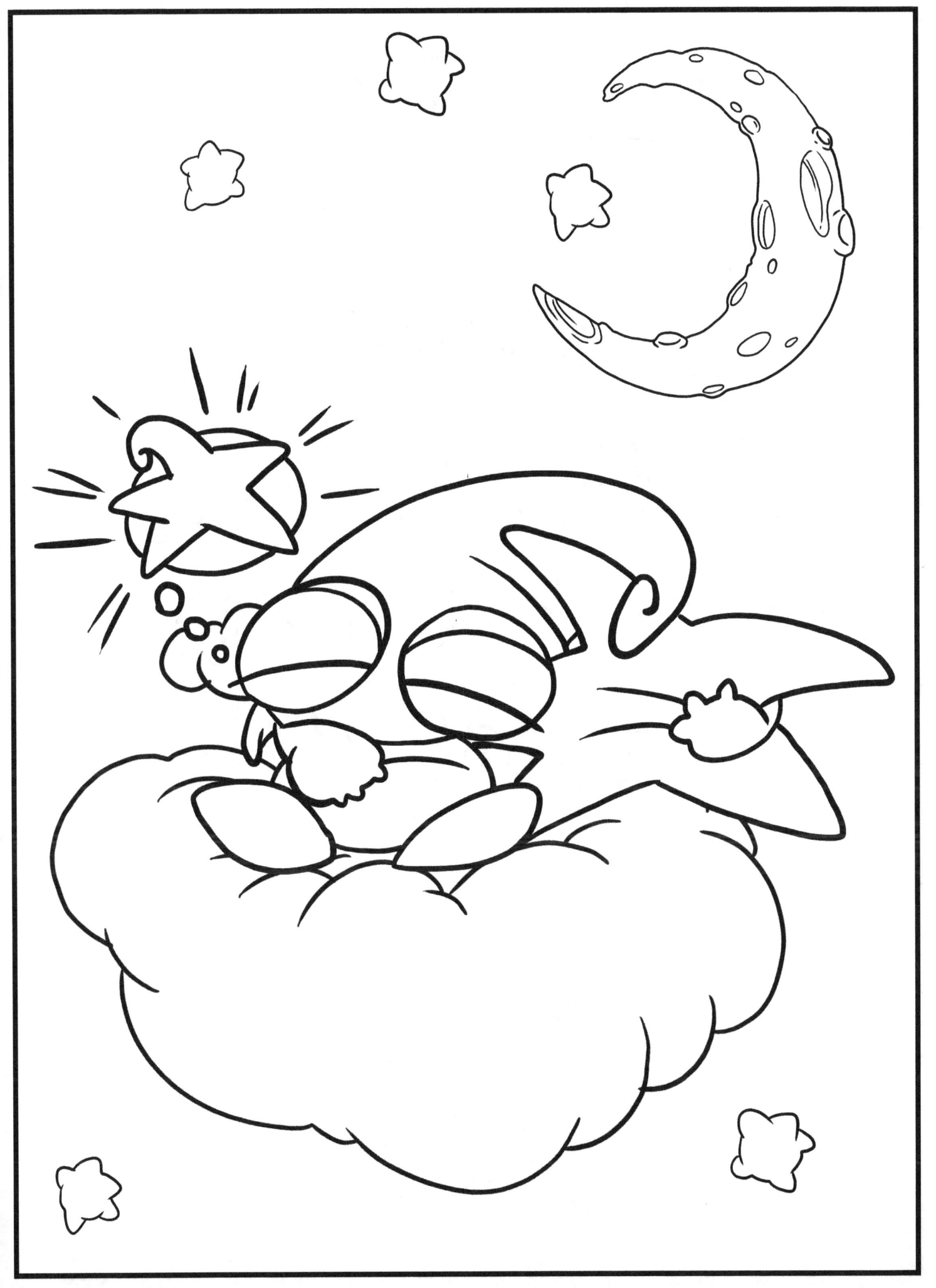

...chasing after Mira, along a star trail!

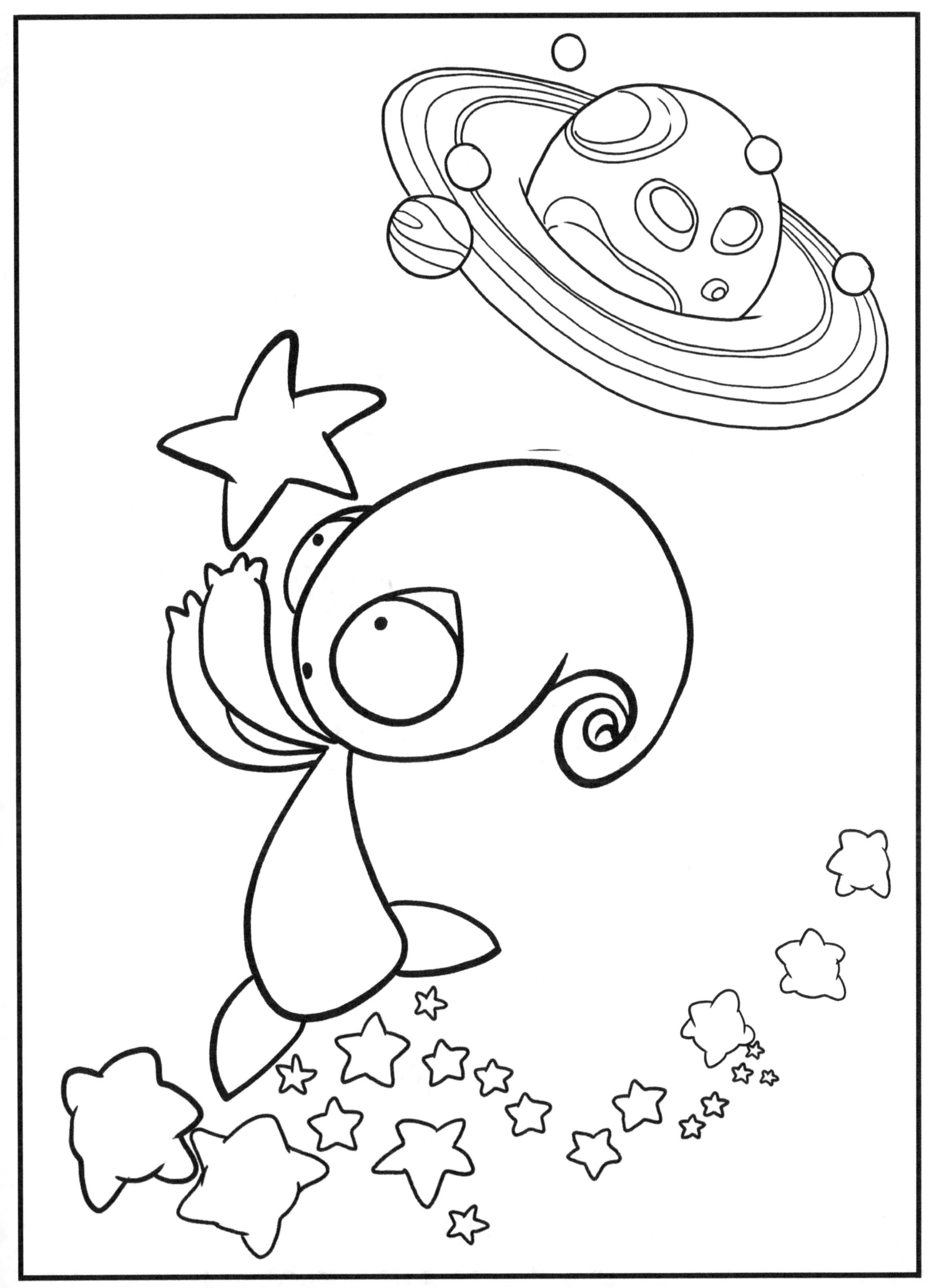

...getting a stellar halo, after being good!

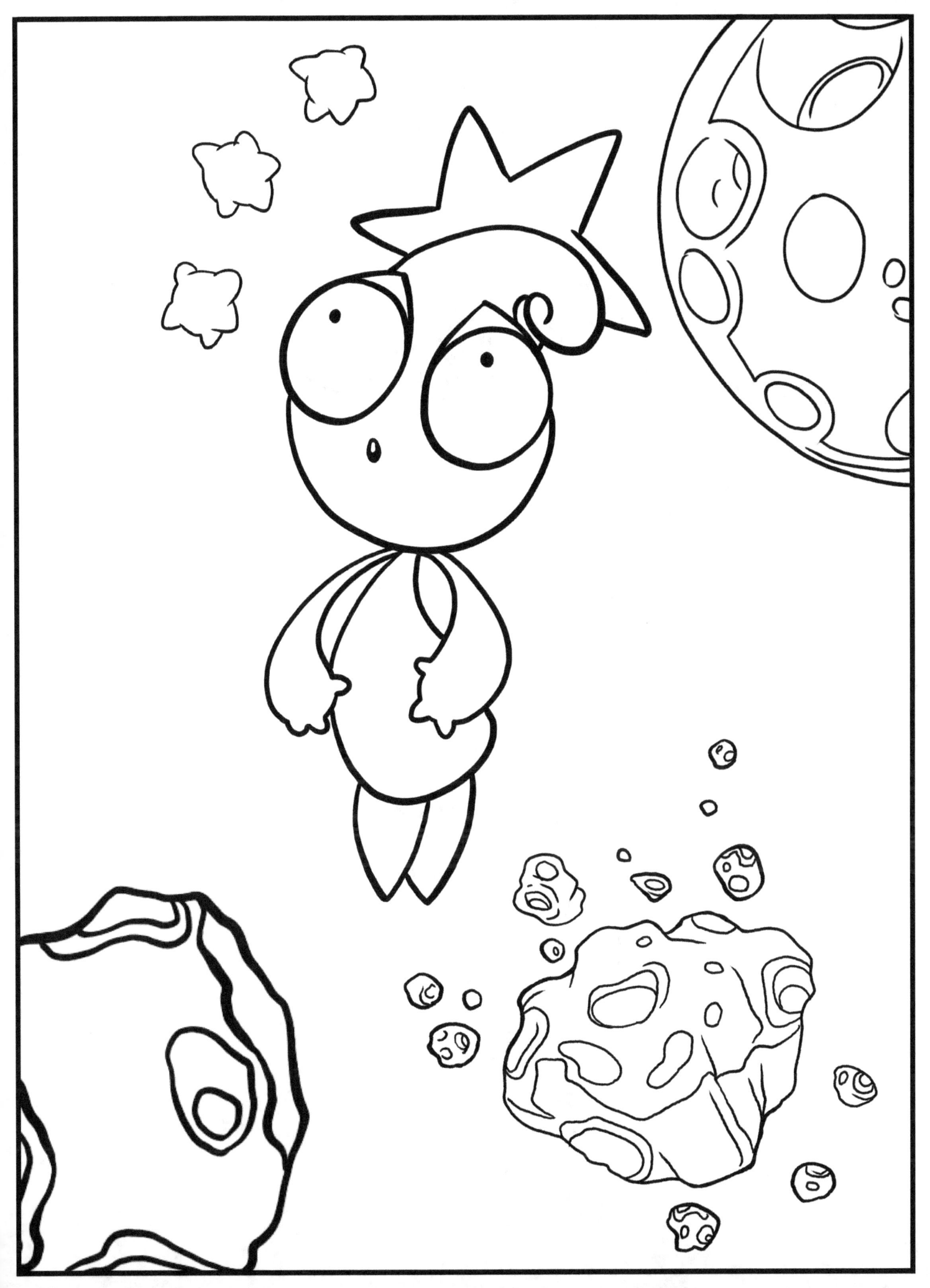

...fishing in the sea of stars!

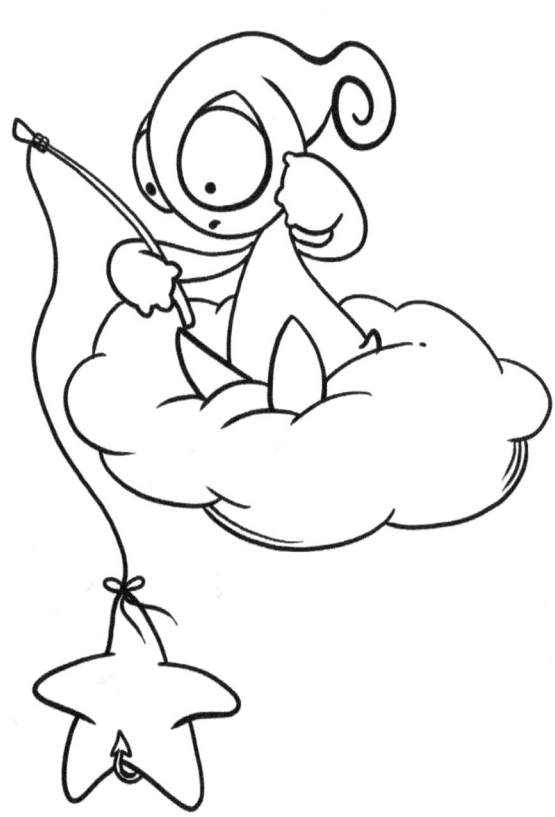

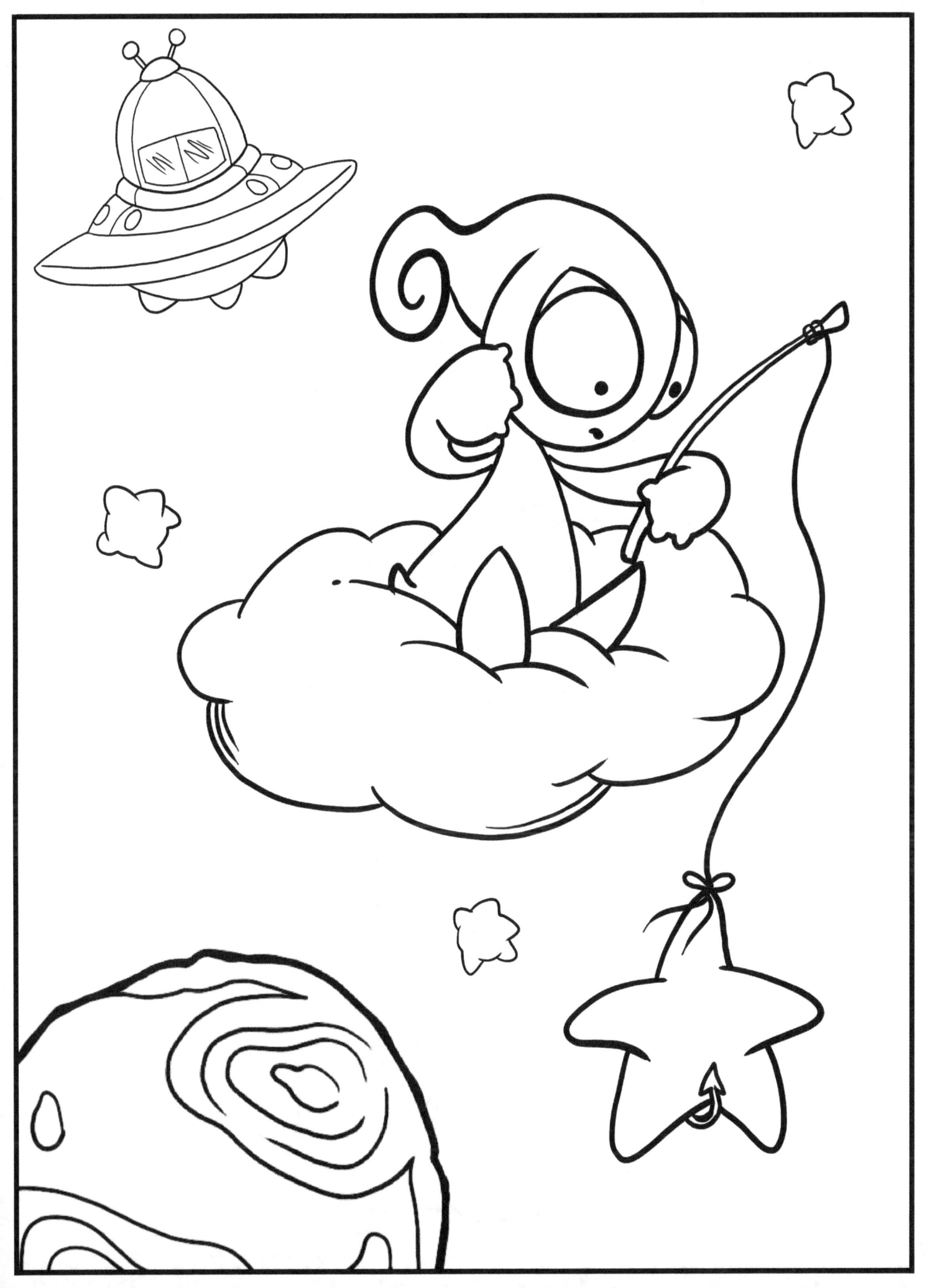

...TAKING A MULTI-COLOR SHOWER!

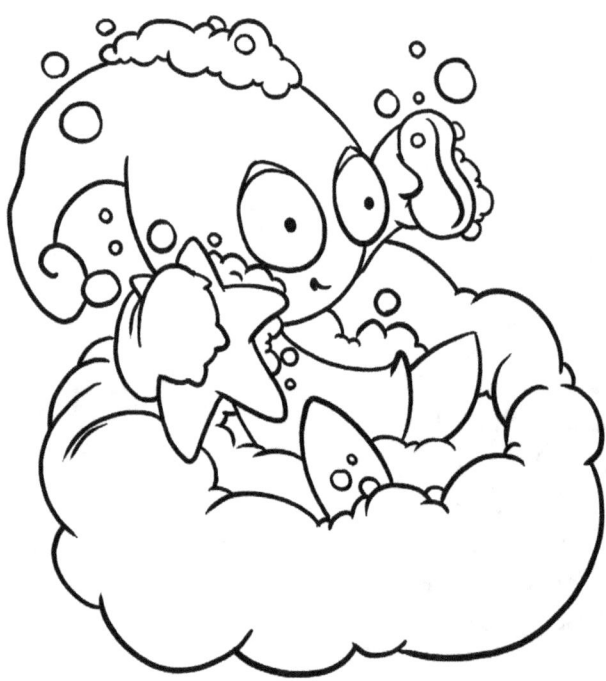

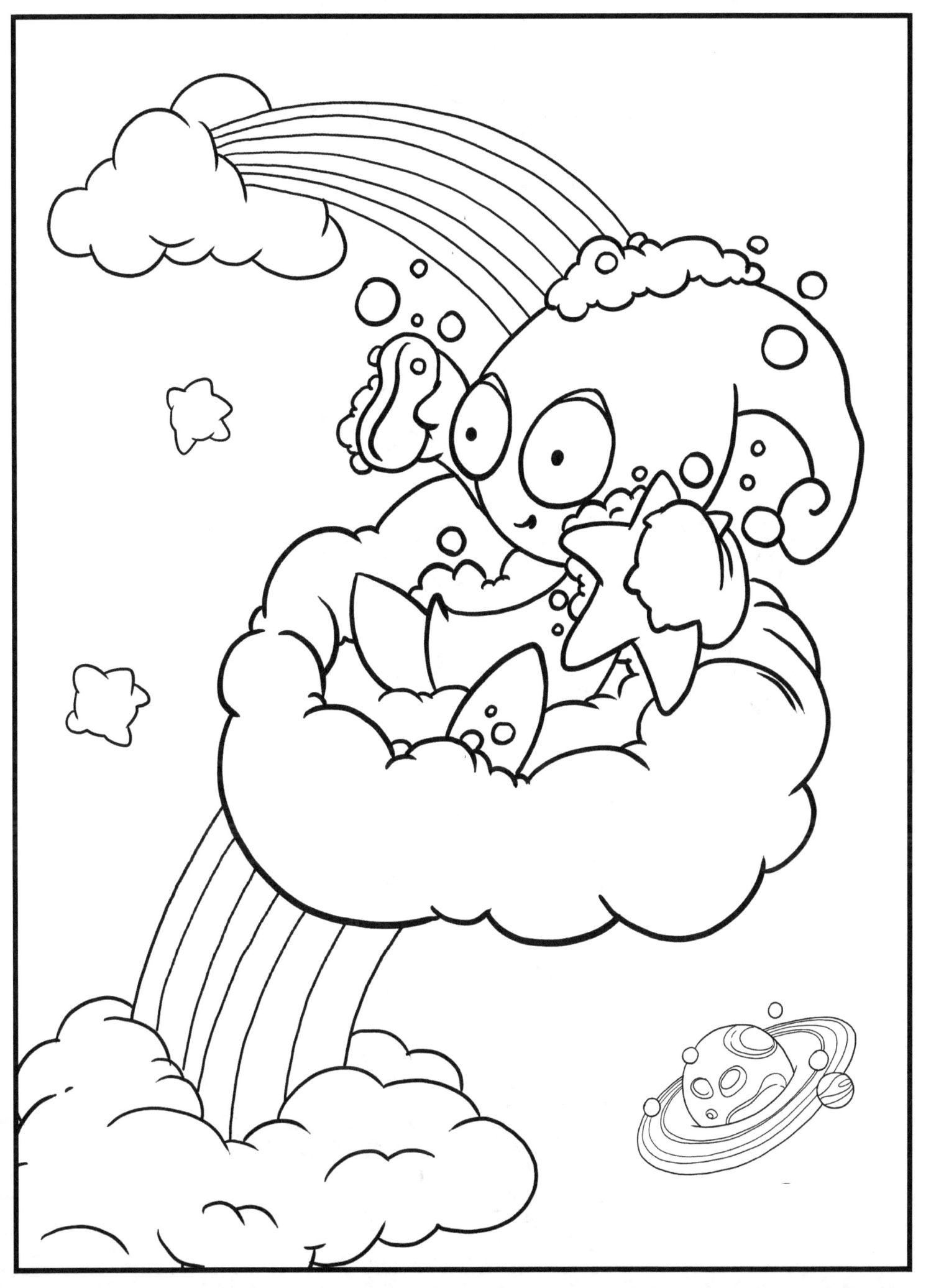

...SKY-BOARDING IN DEEP SPACE!

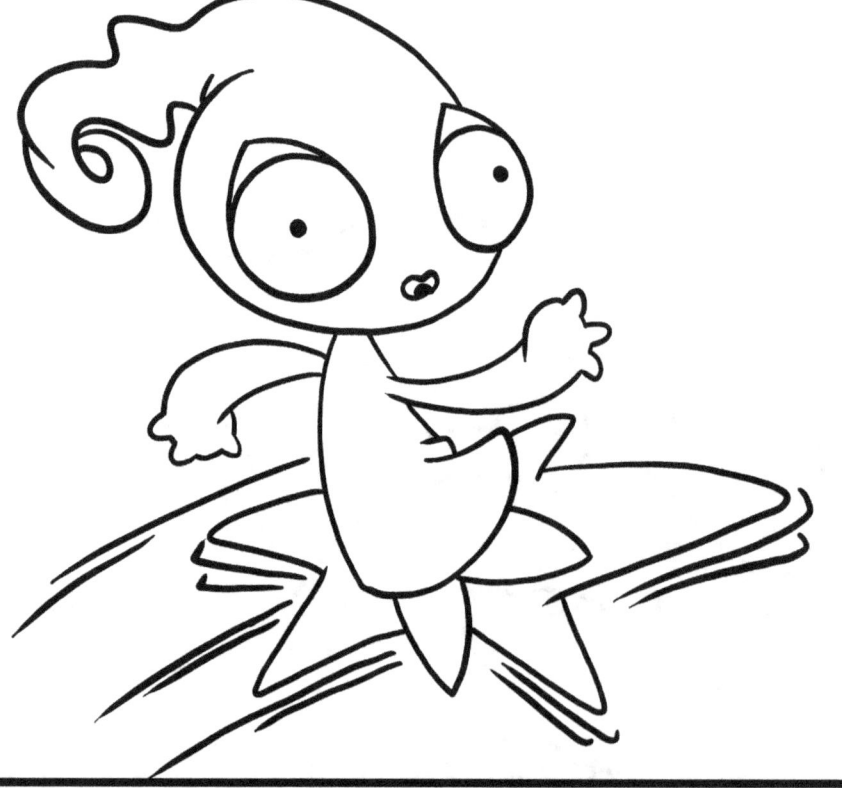

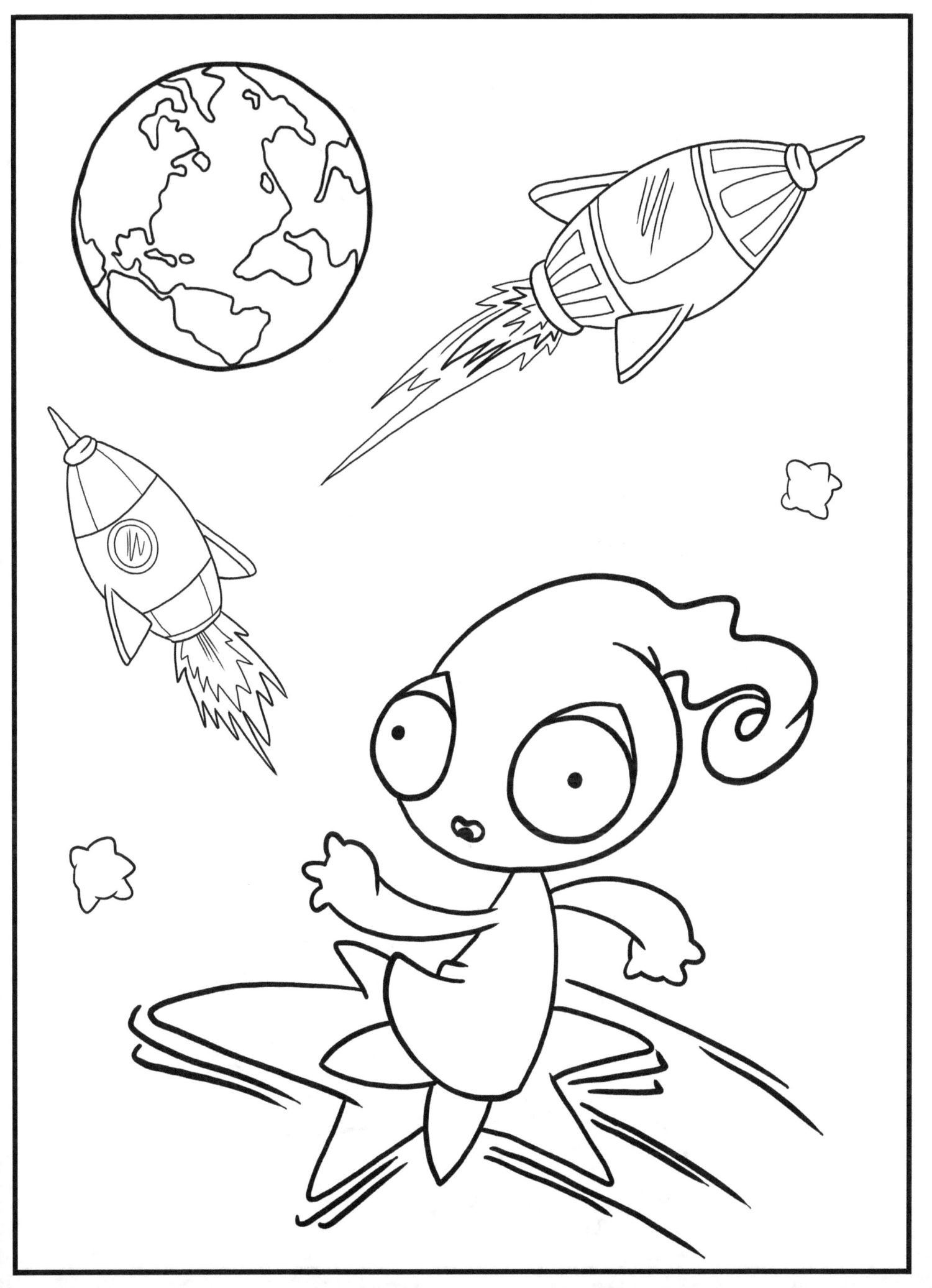

...SUDDENLY WAKING-UP AFTER A NAP!

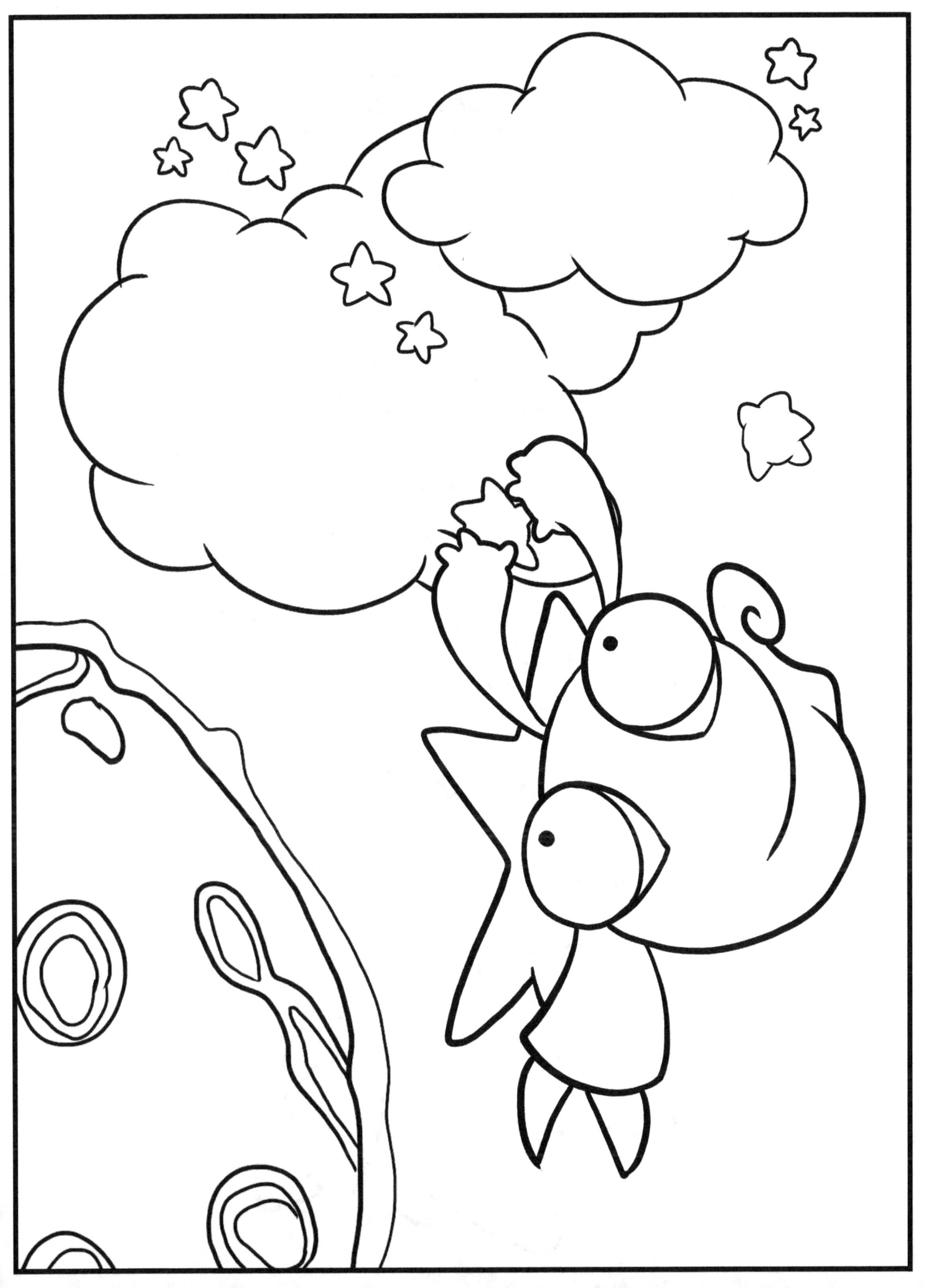

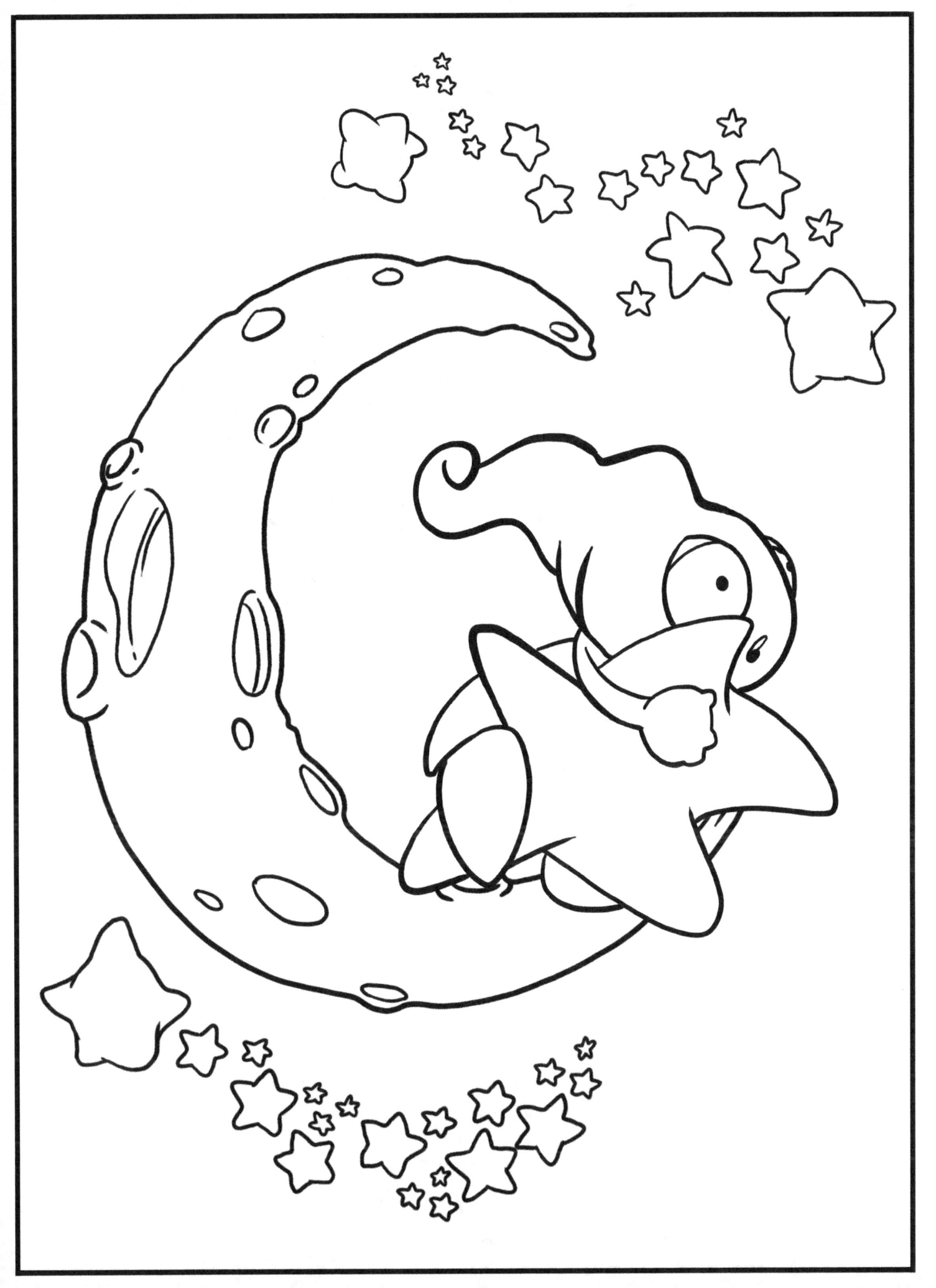

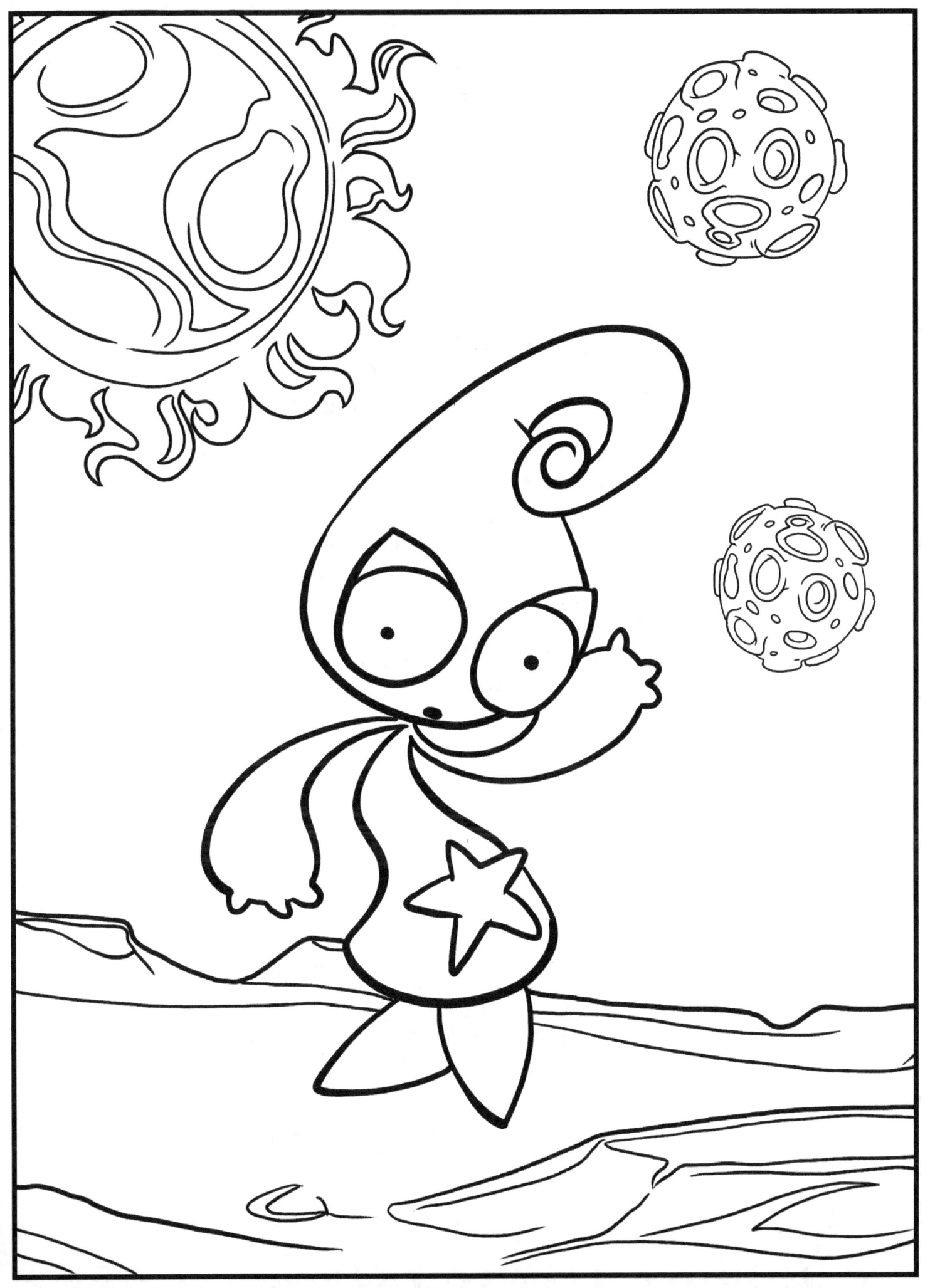

...RUSHING AT THE PLANET'S RINGS!

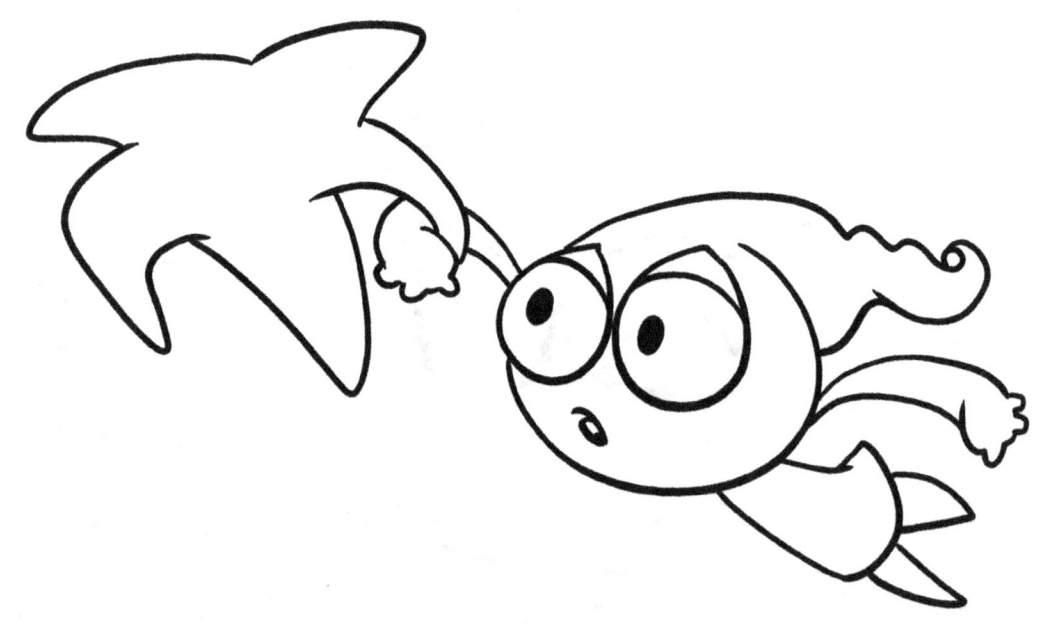

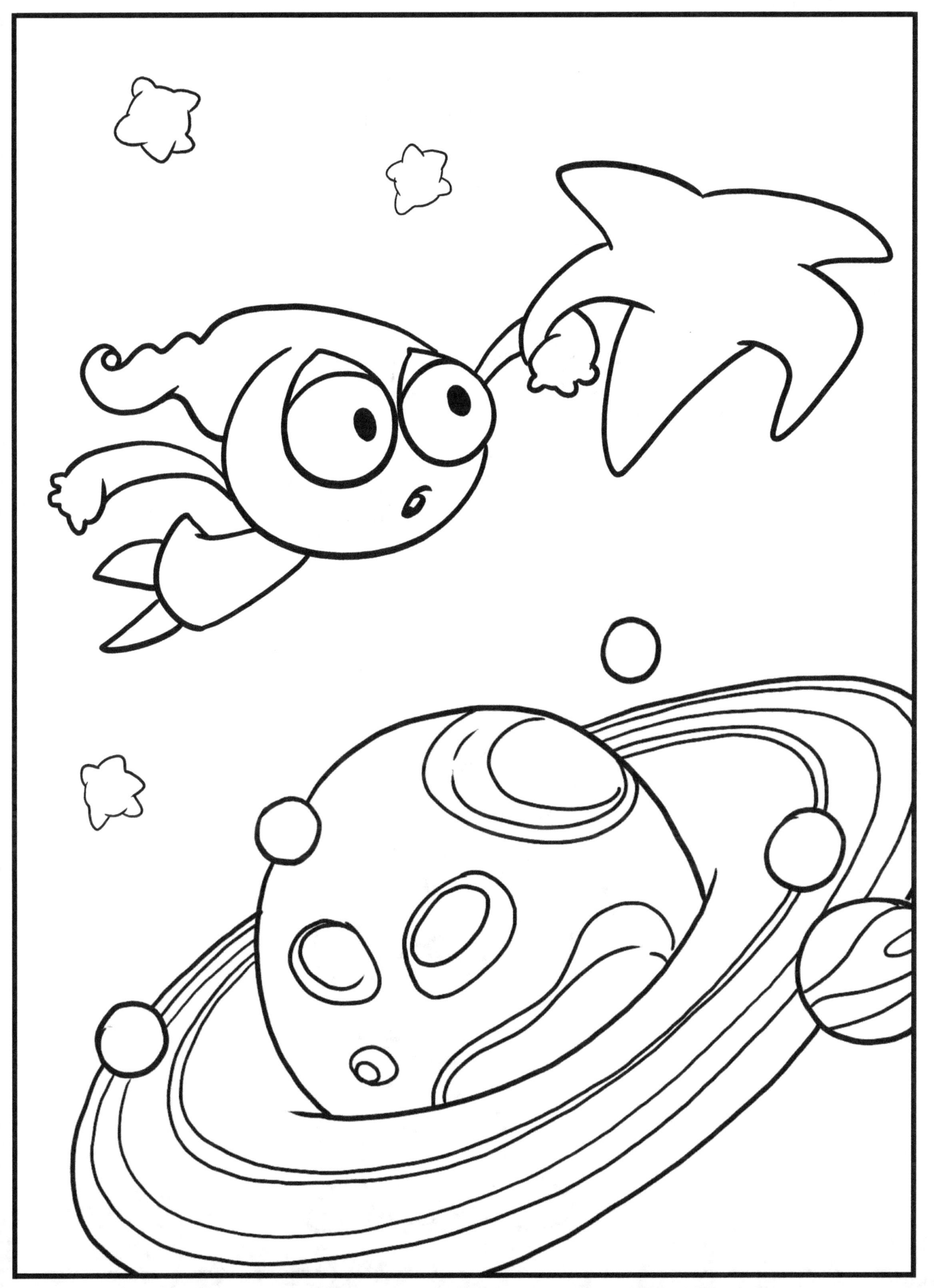

...TESTING COSMIC BALANCE!

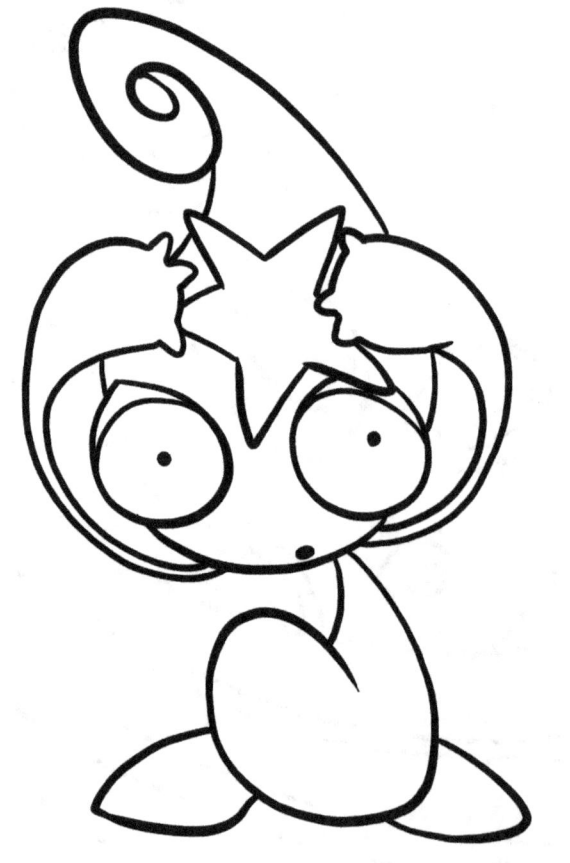

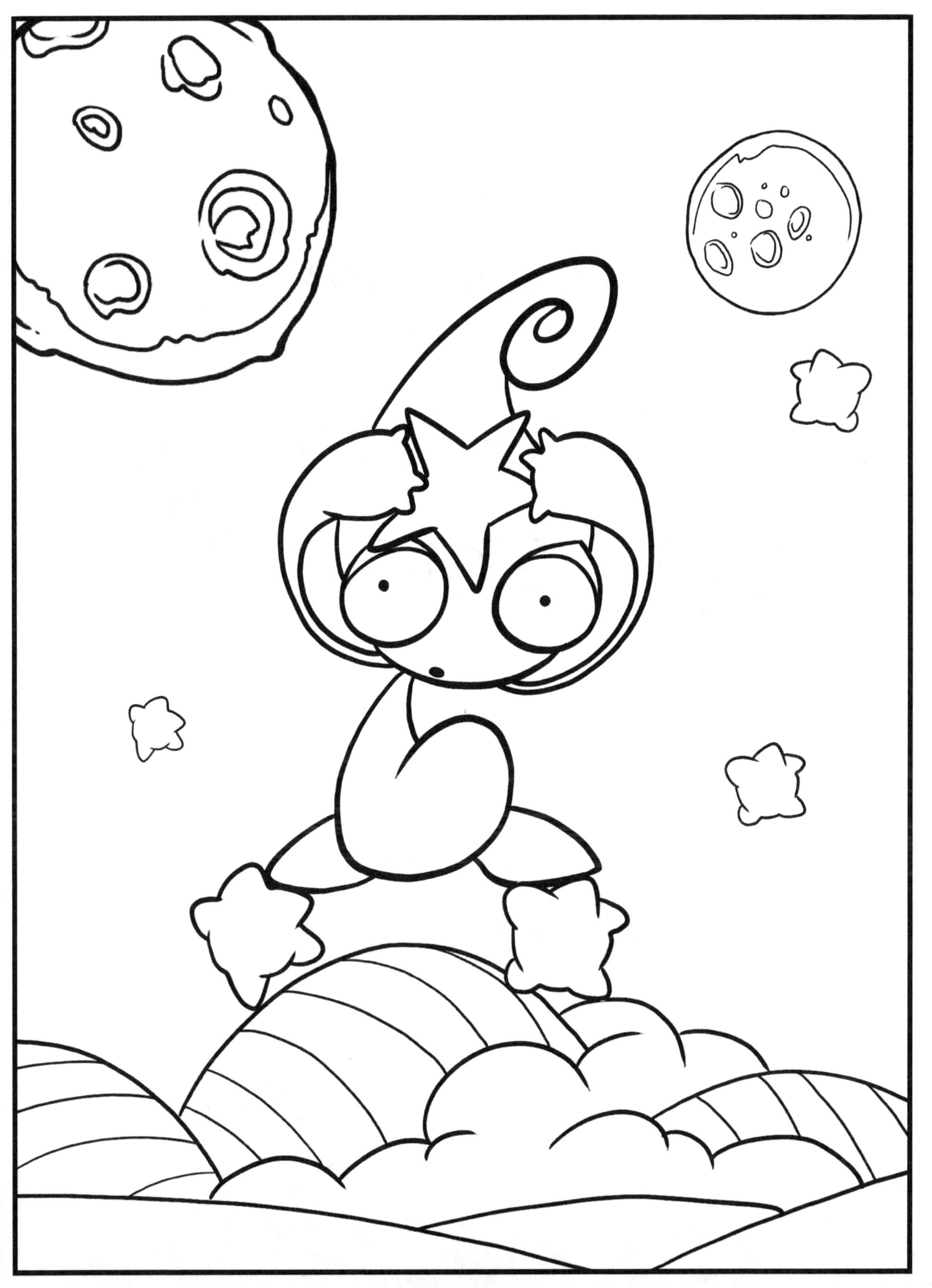

....FLYING A KITE THROUGH THE STARS!

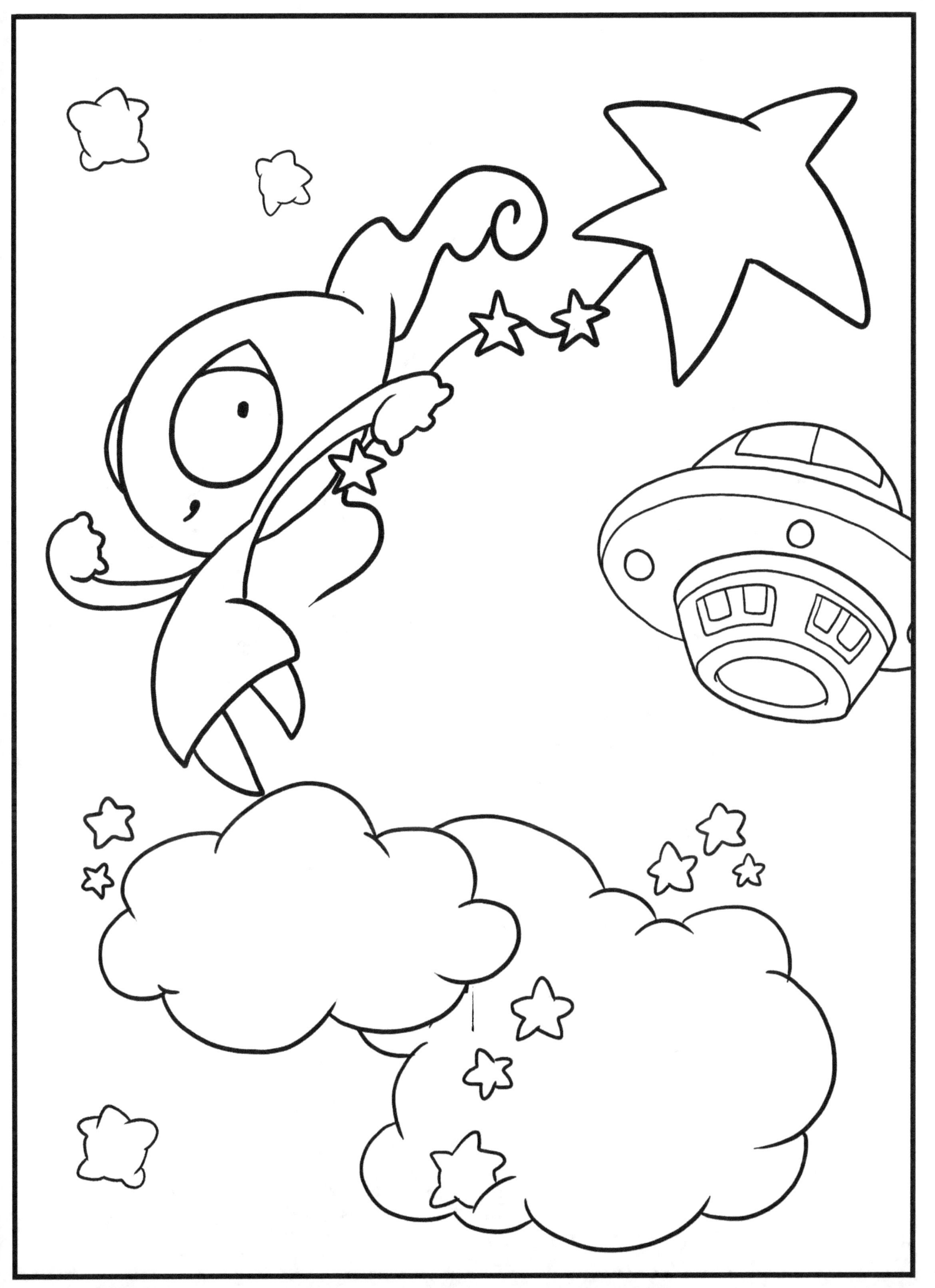

...PAINTING THE STARS IN THE SKY!

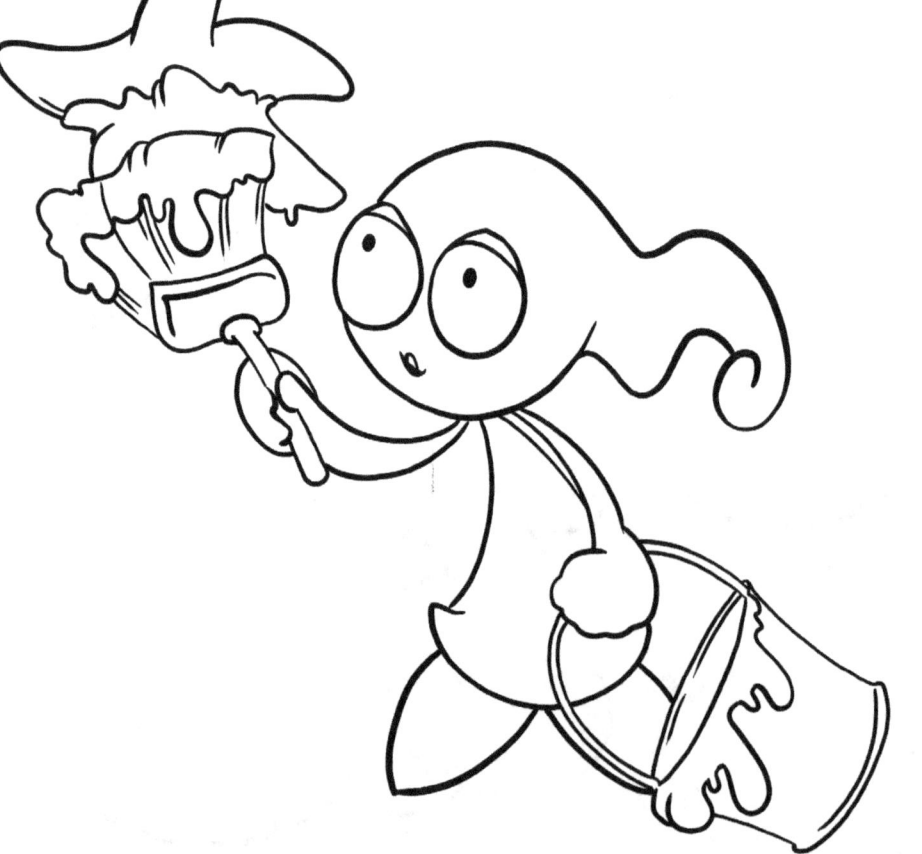

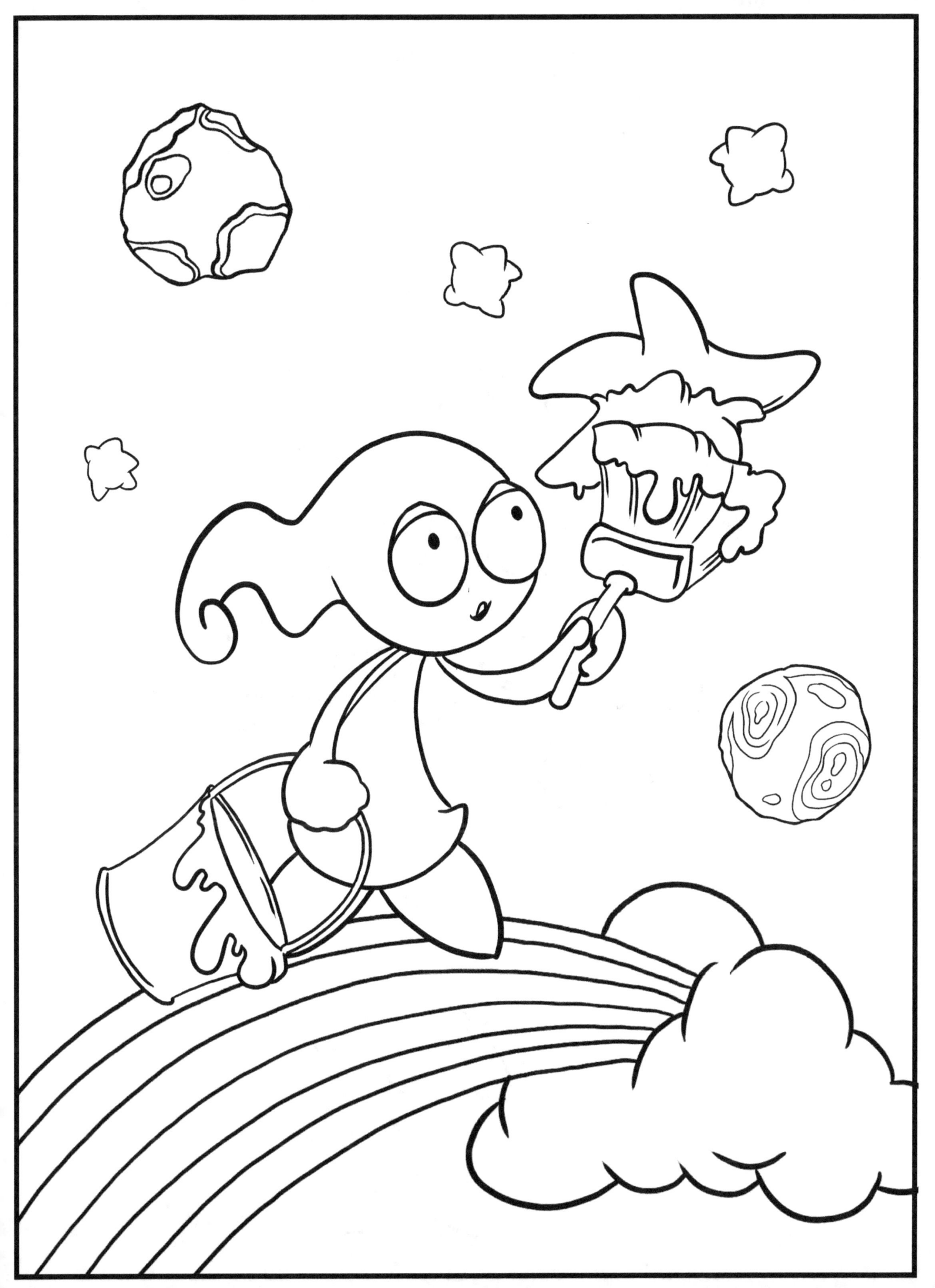

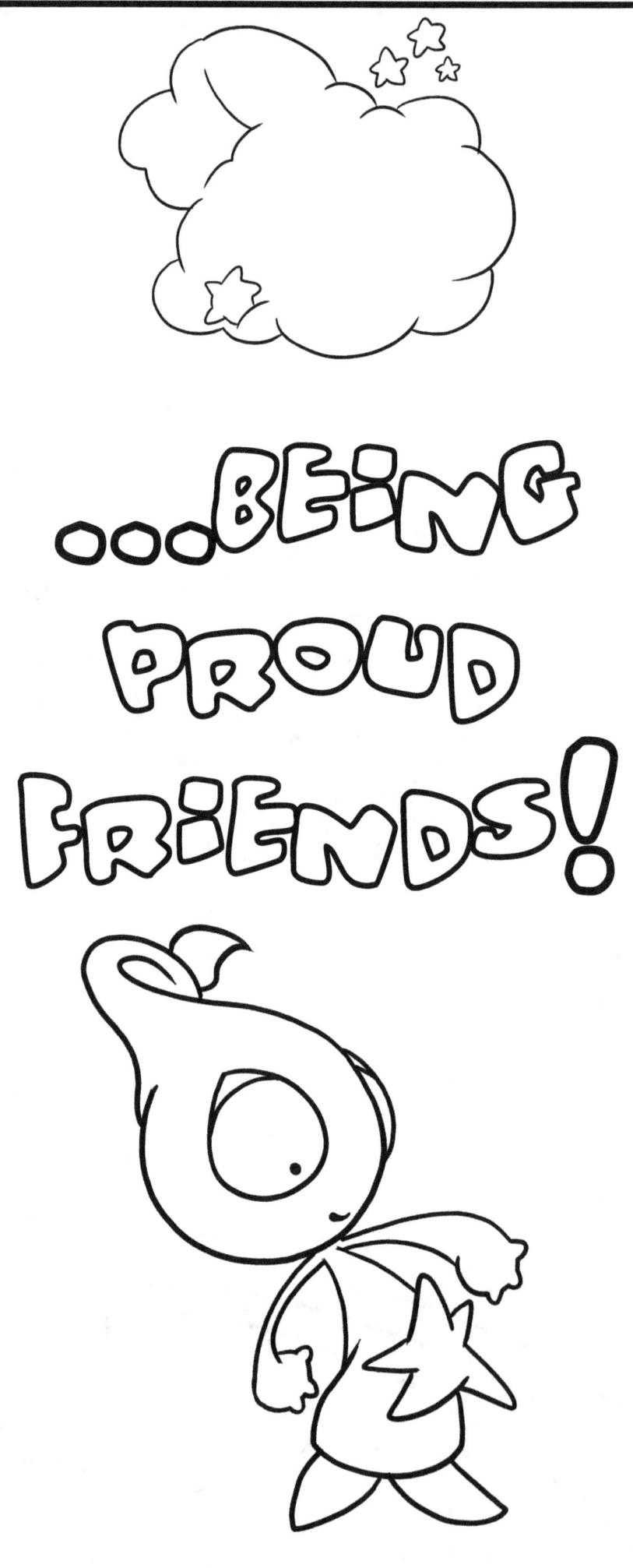

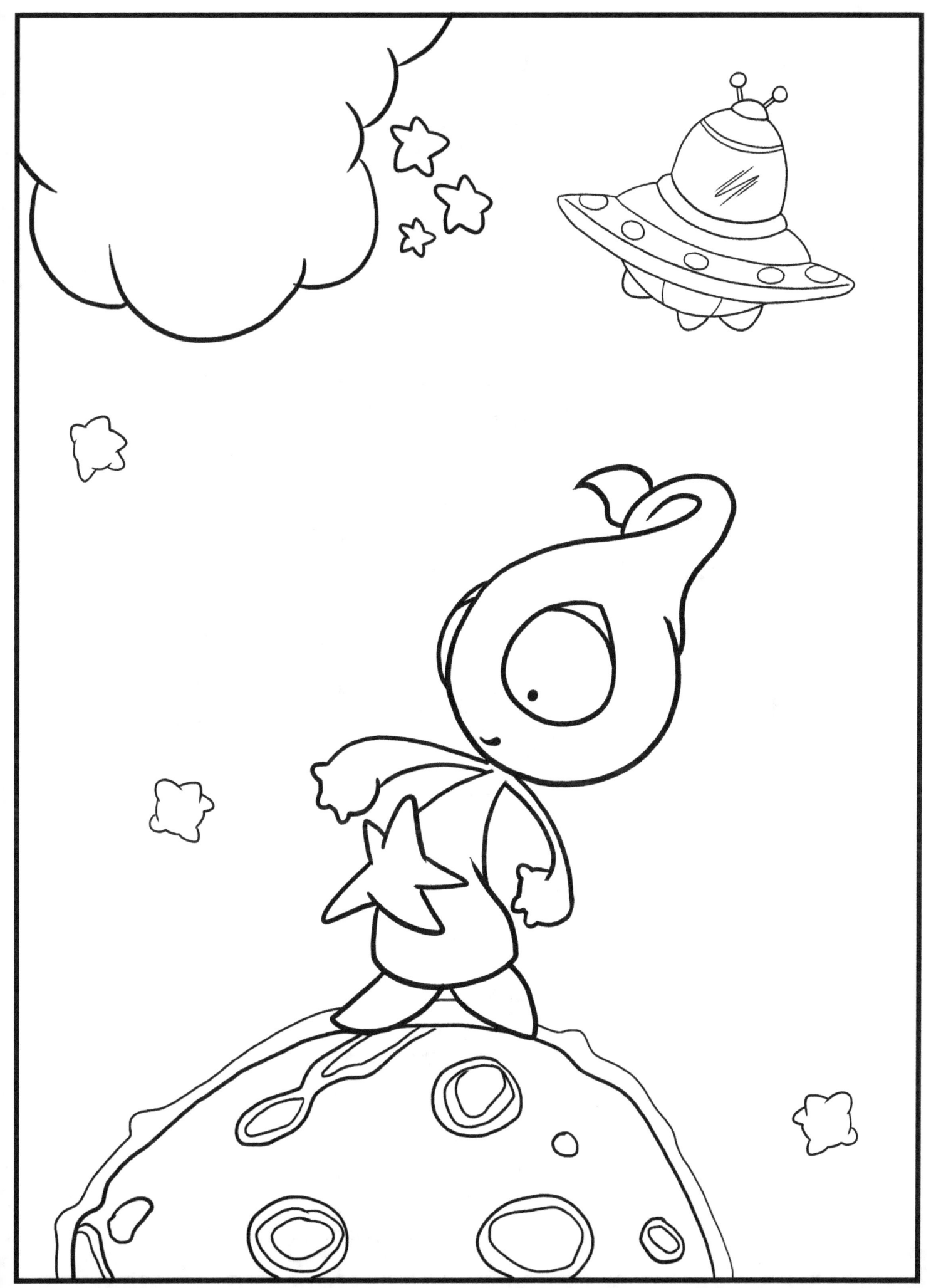

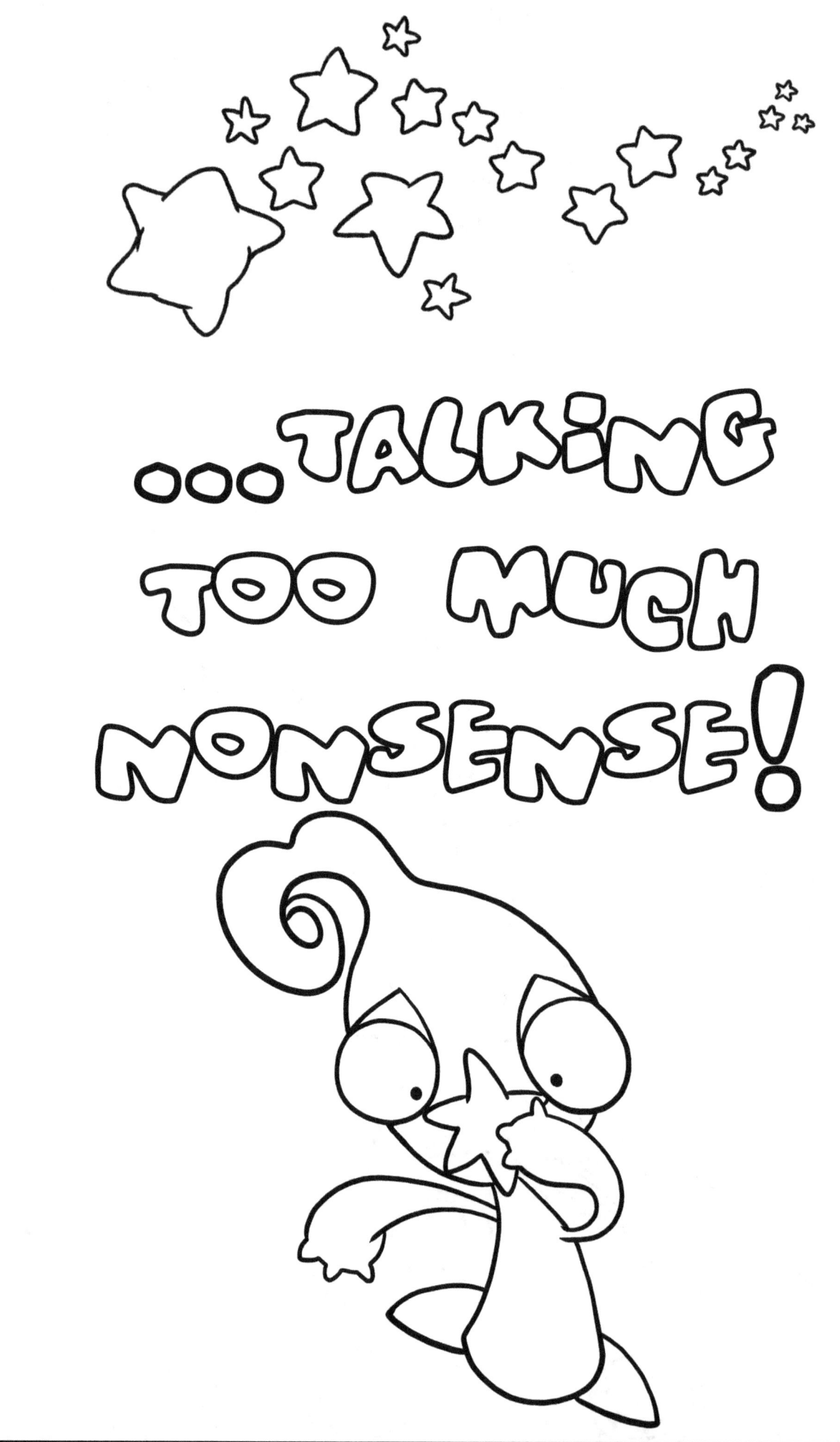

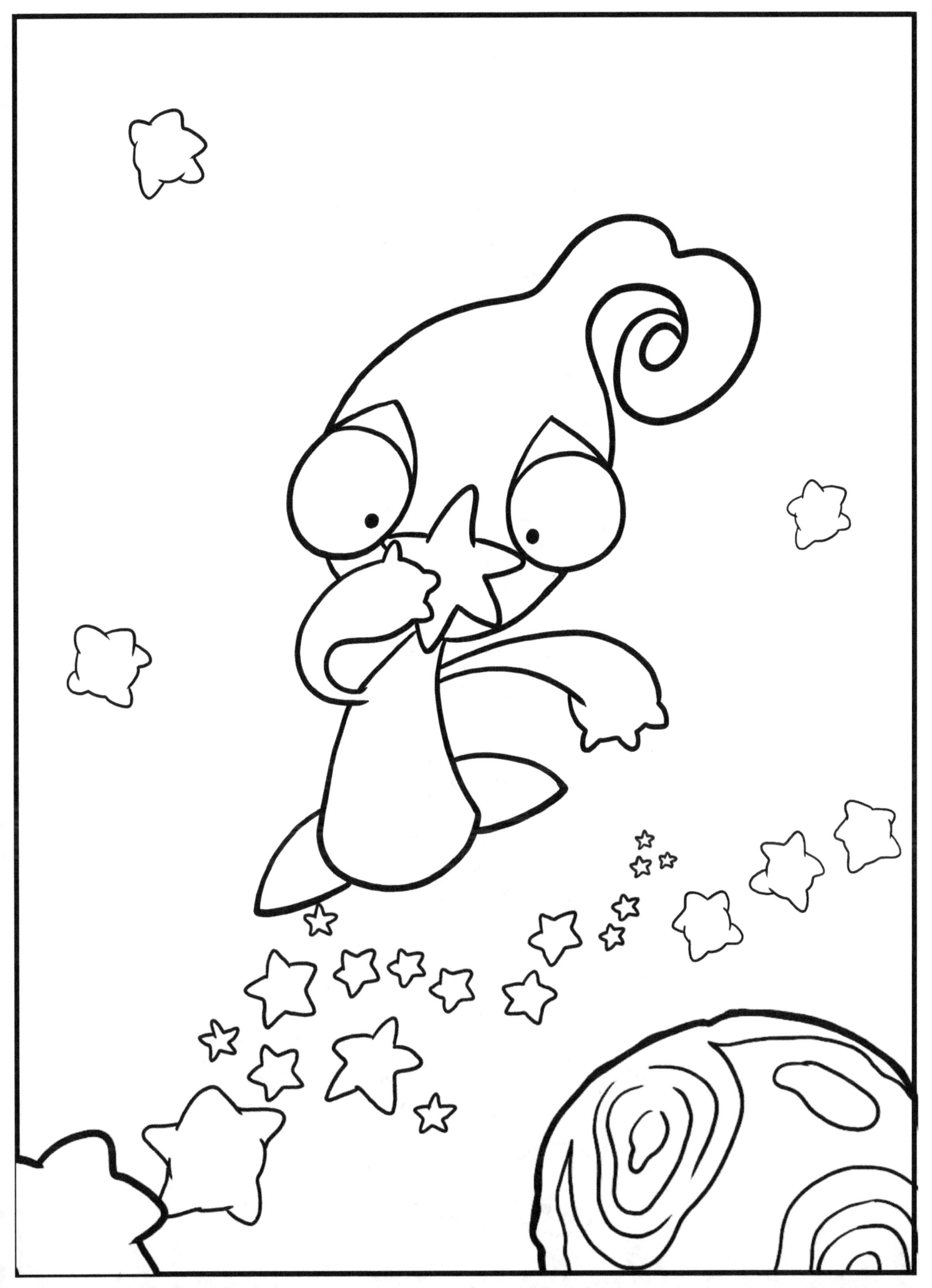

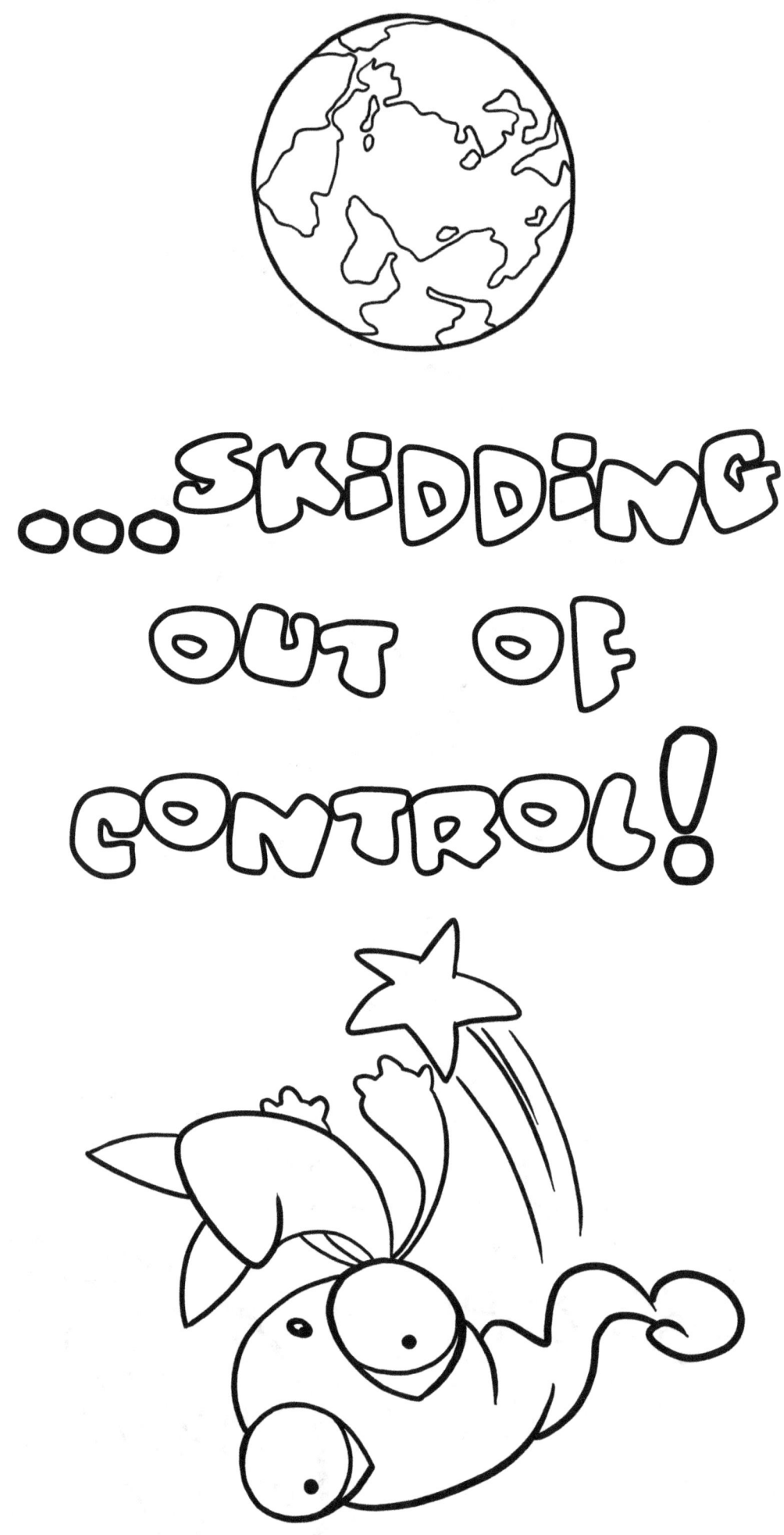

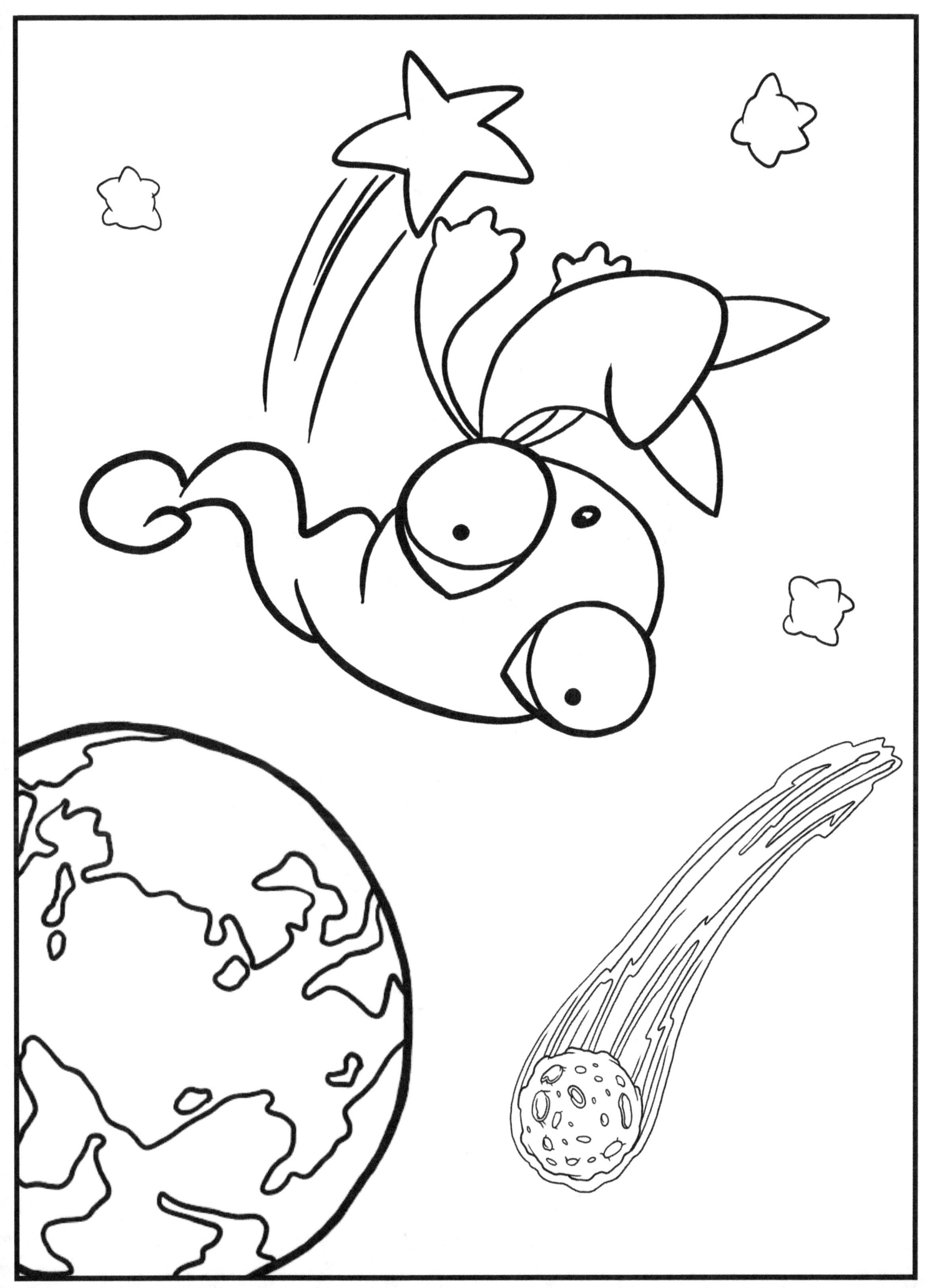

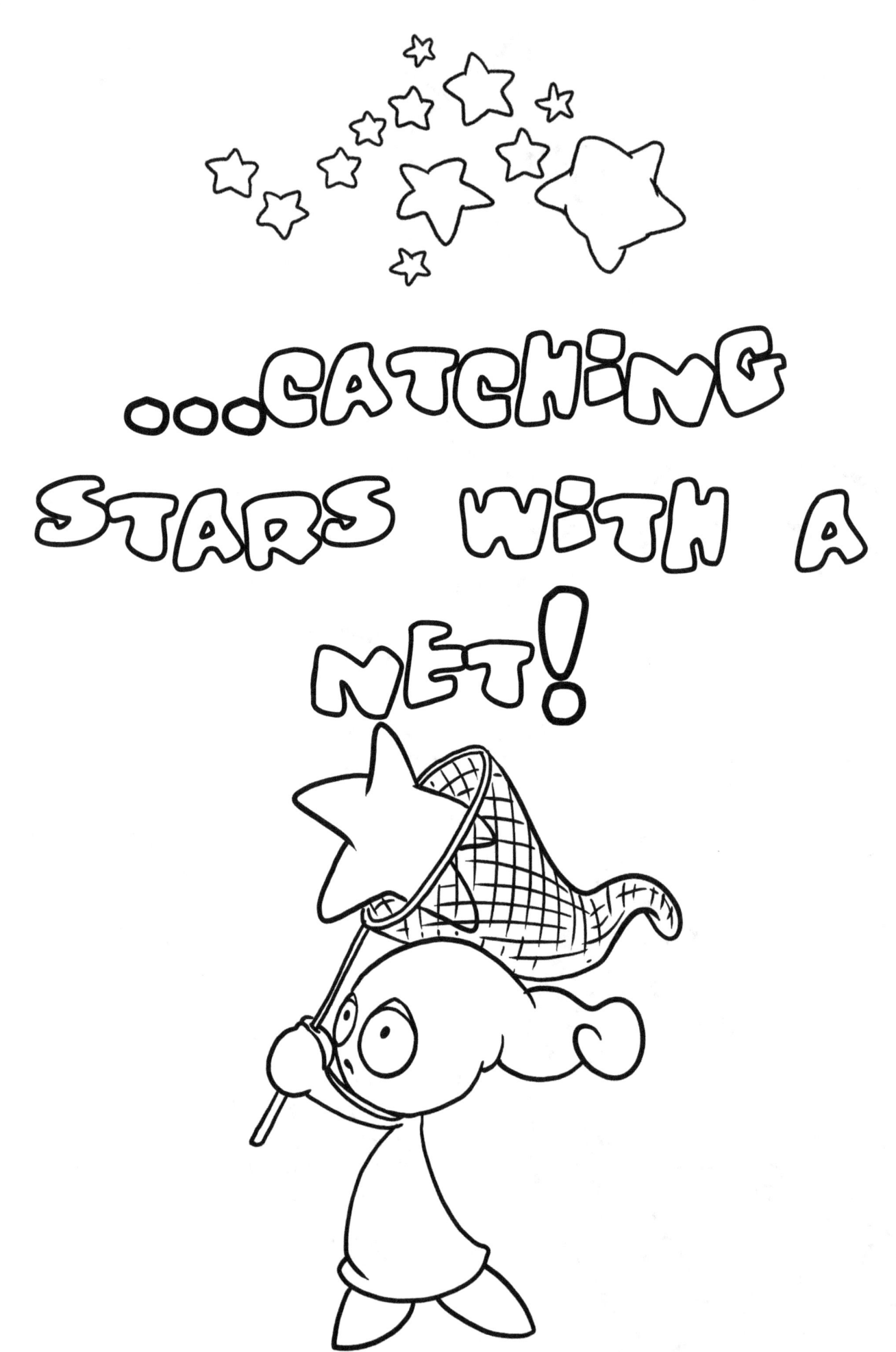

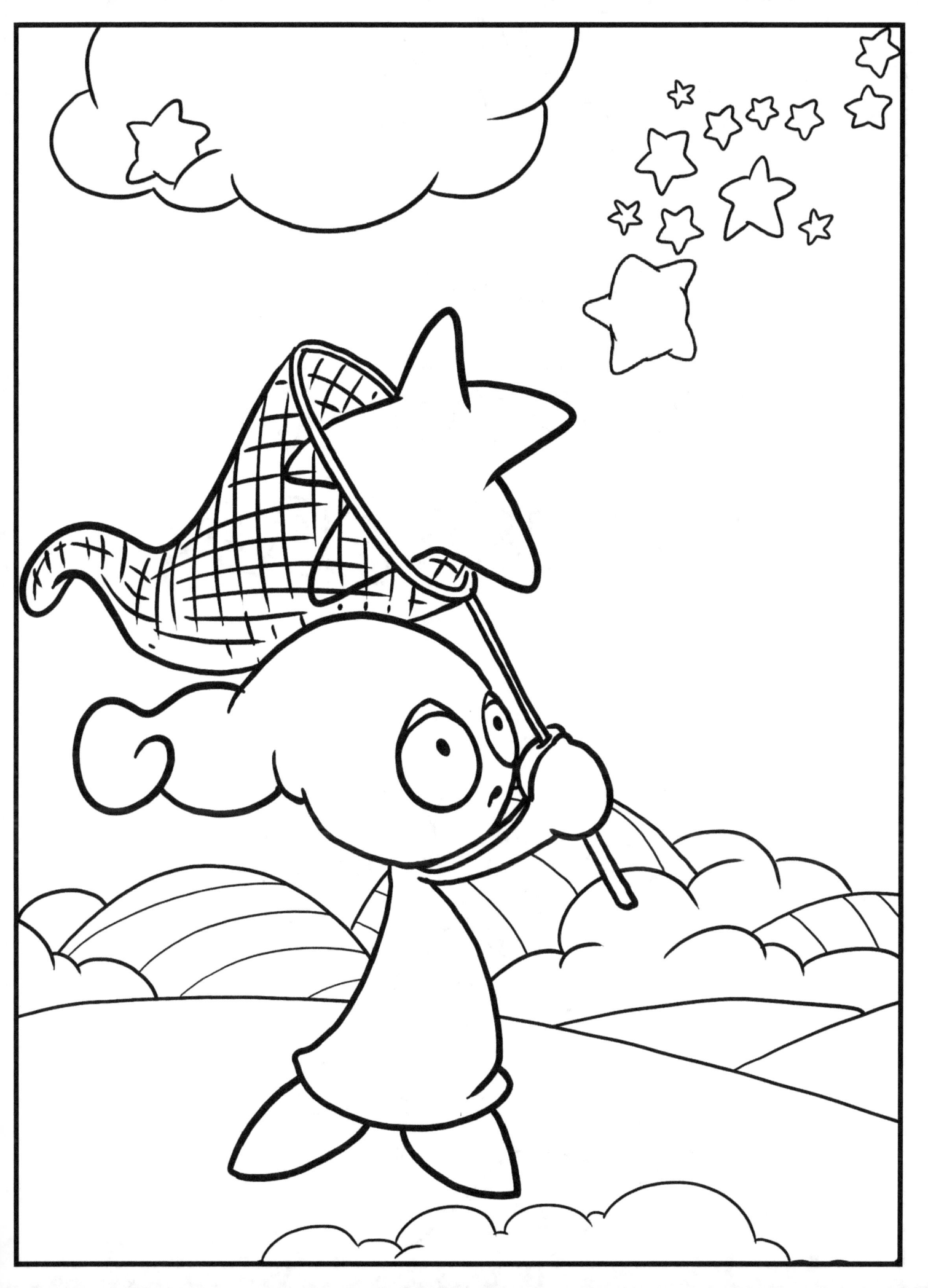

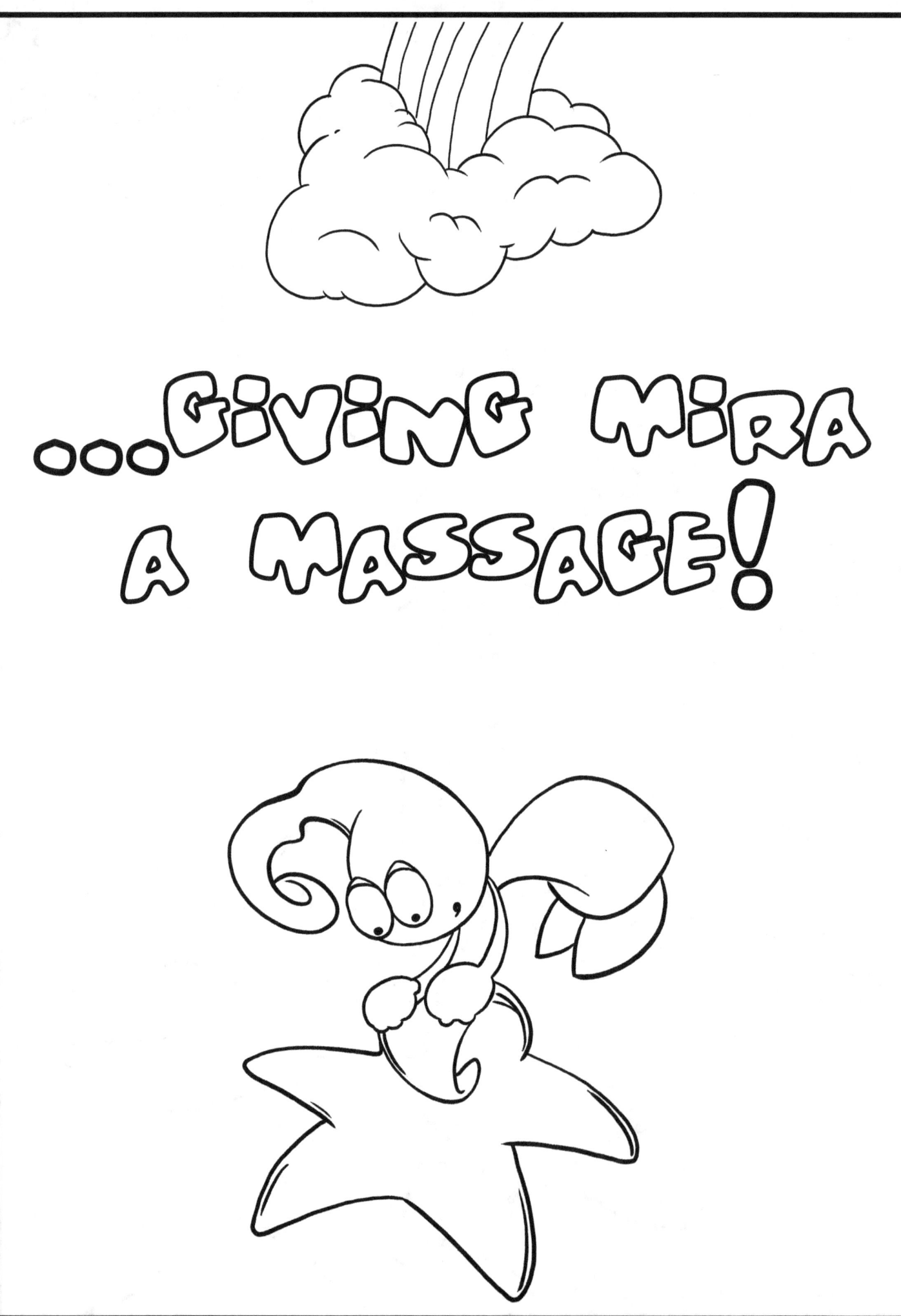

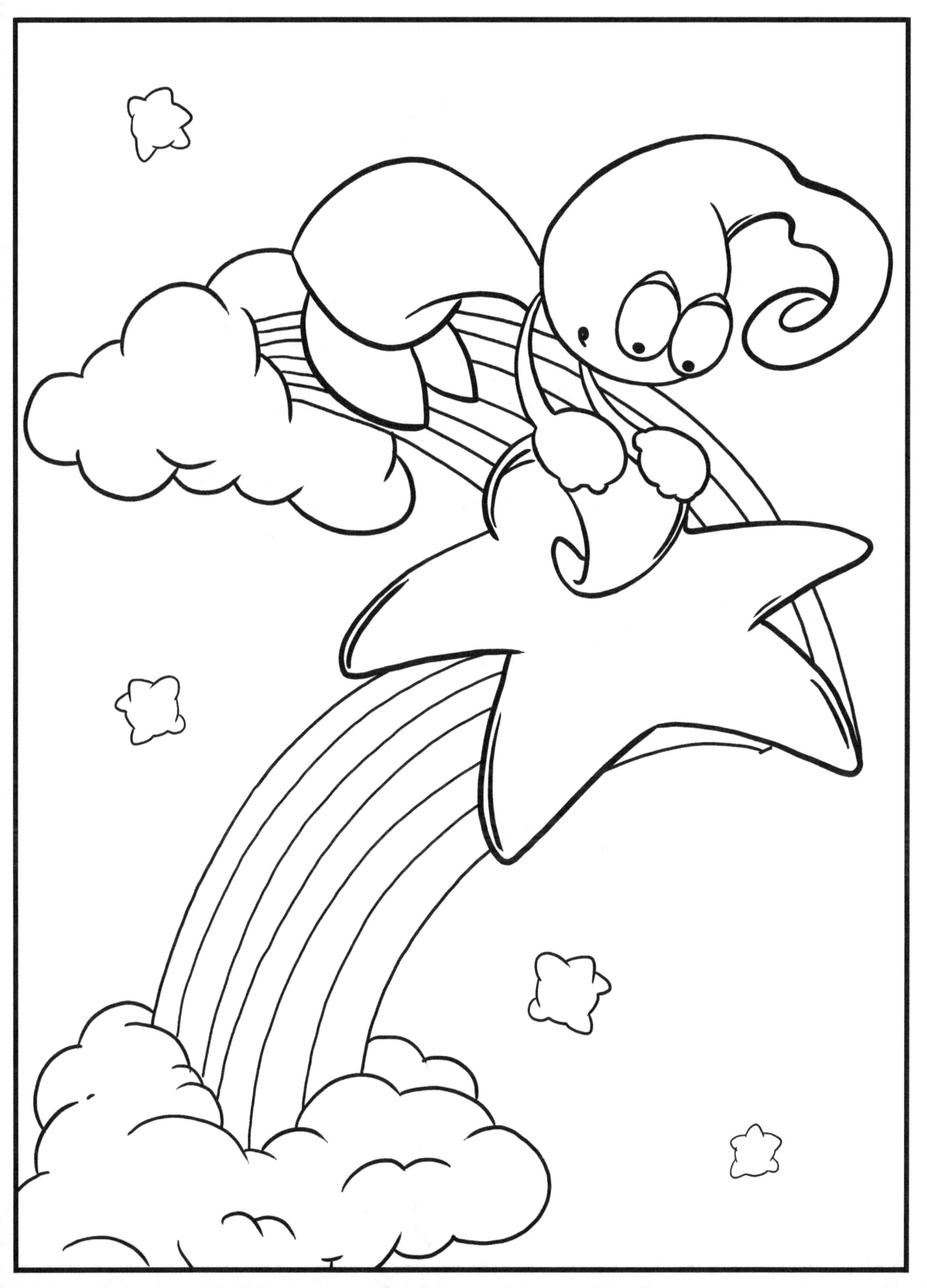

...WALKING UNDER THE BURNING SUN!

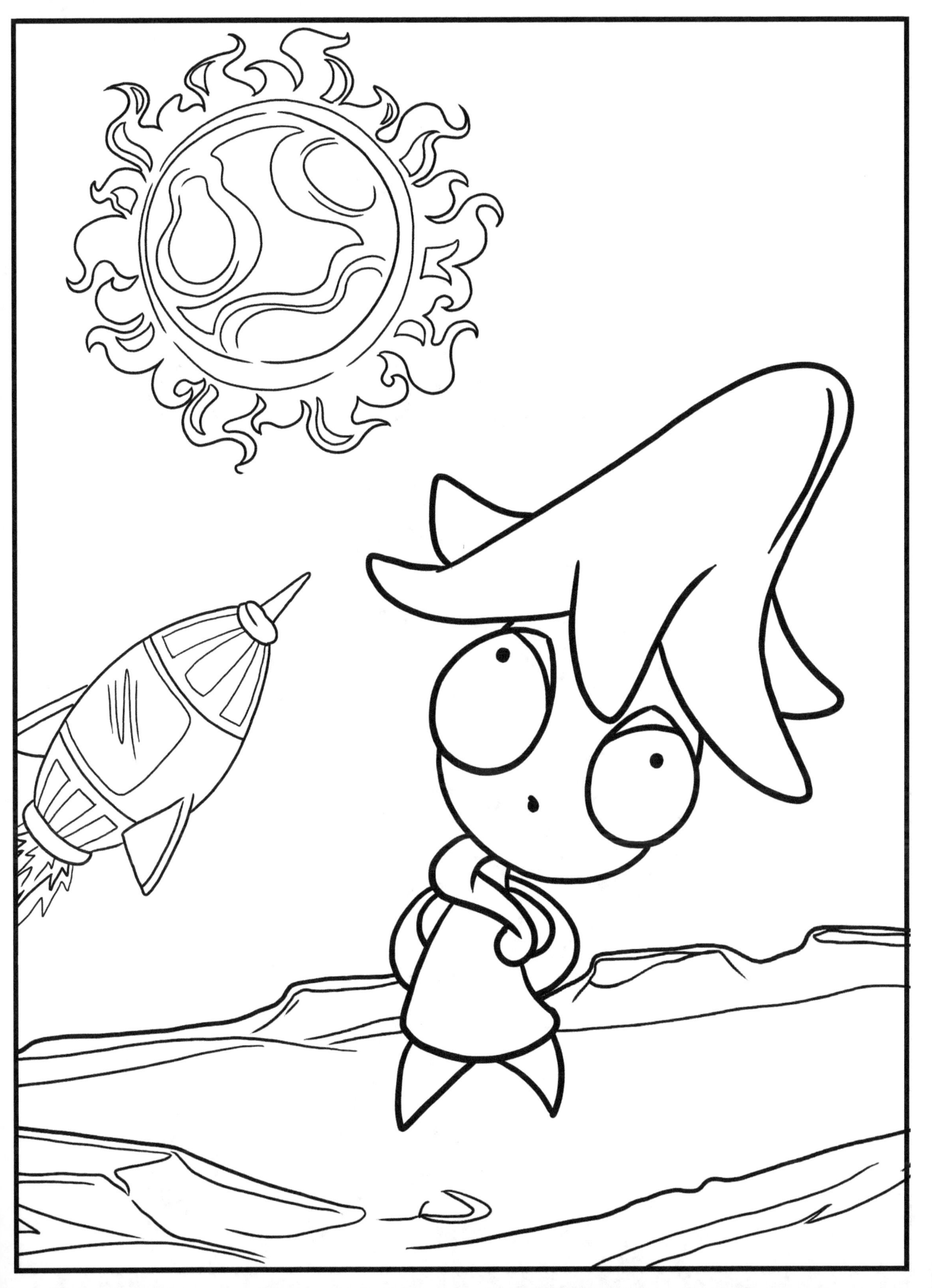

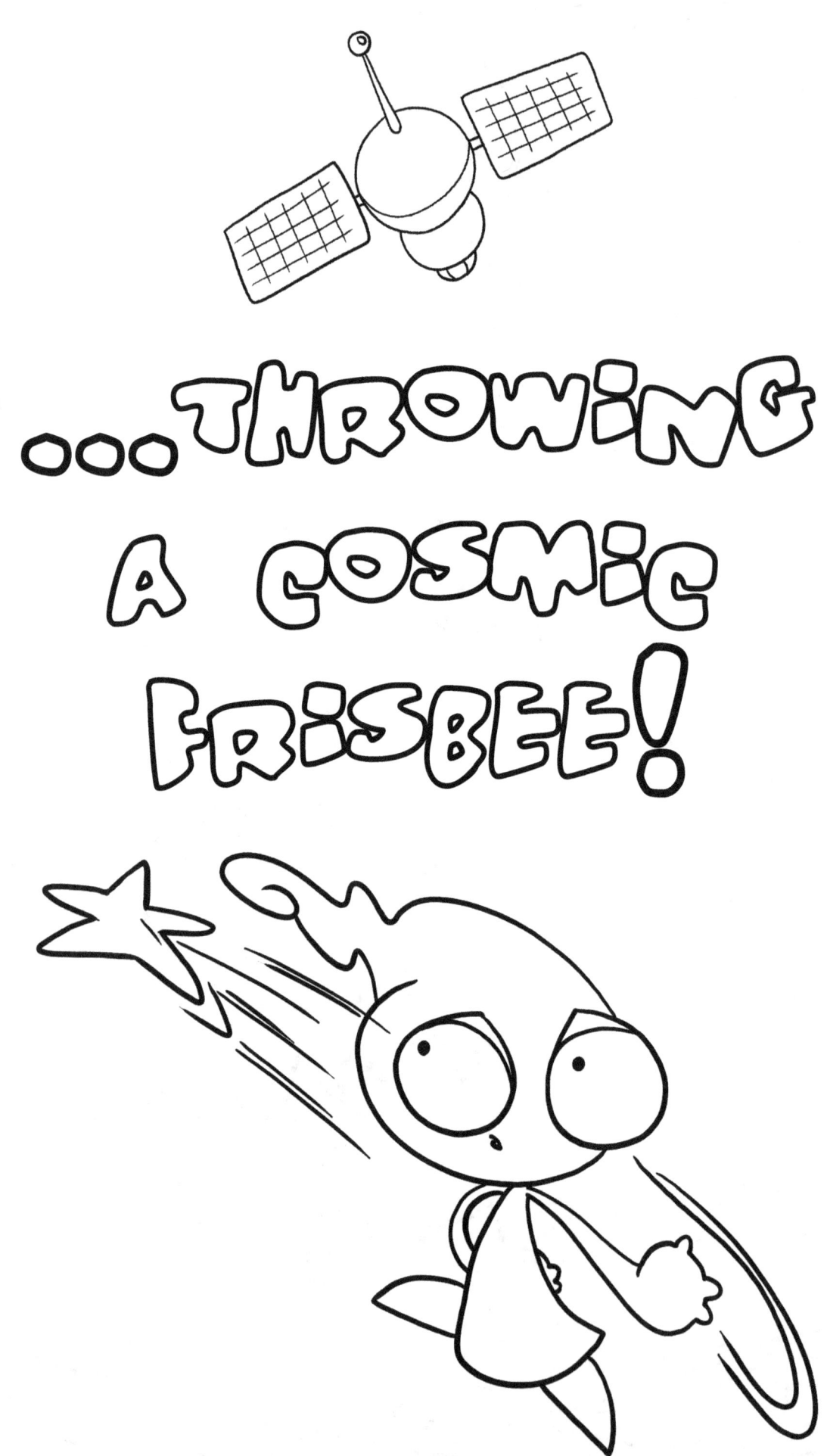

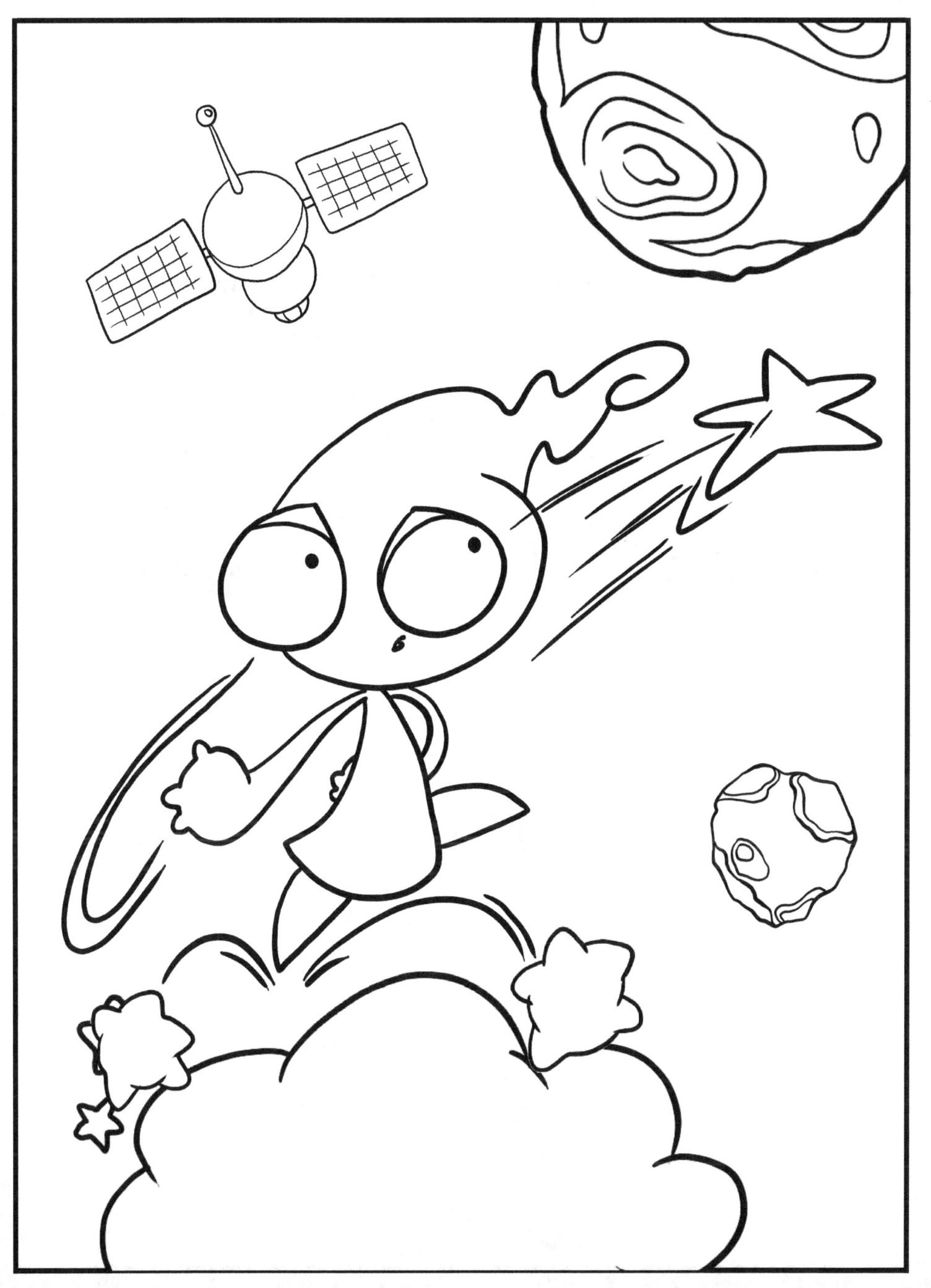

...GETTING STRESSED IN COSMIC JAM!

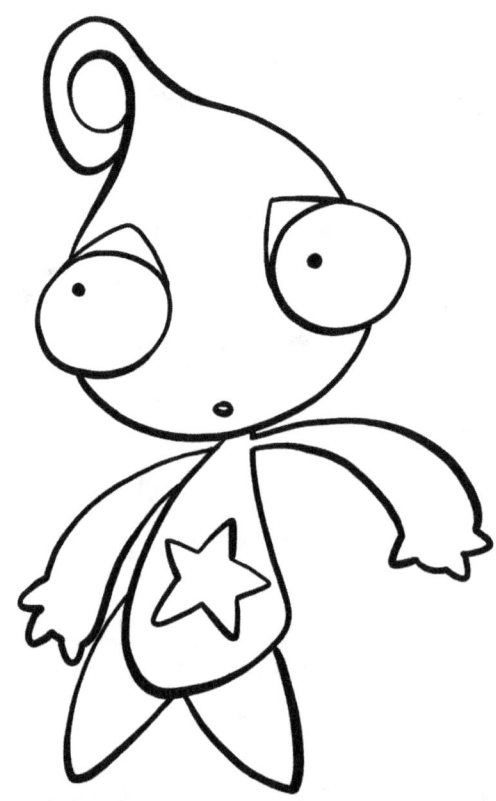

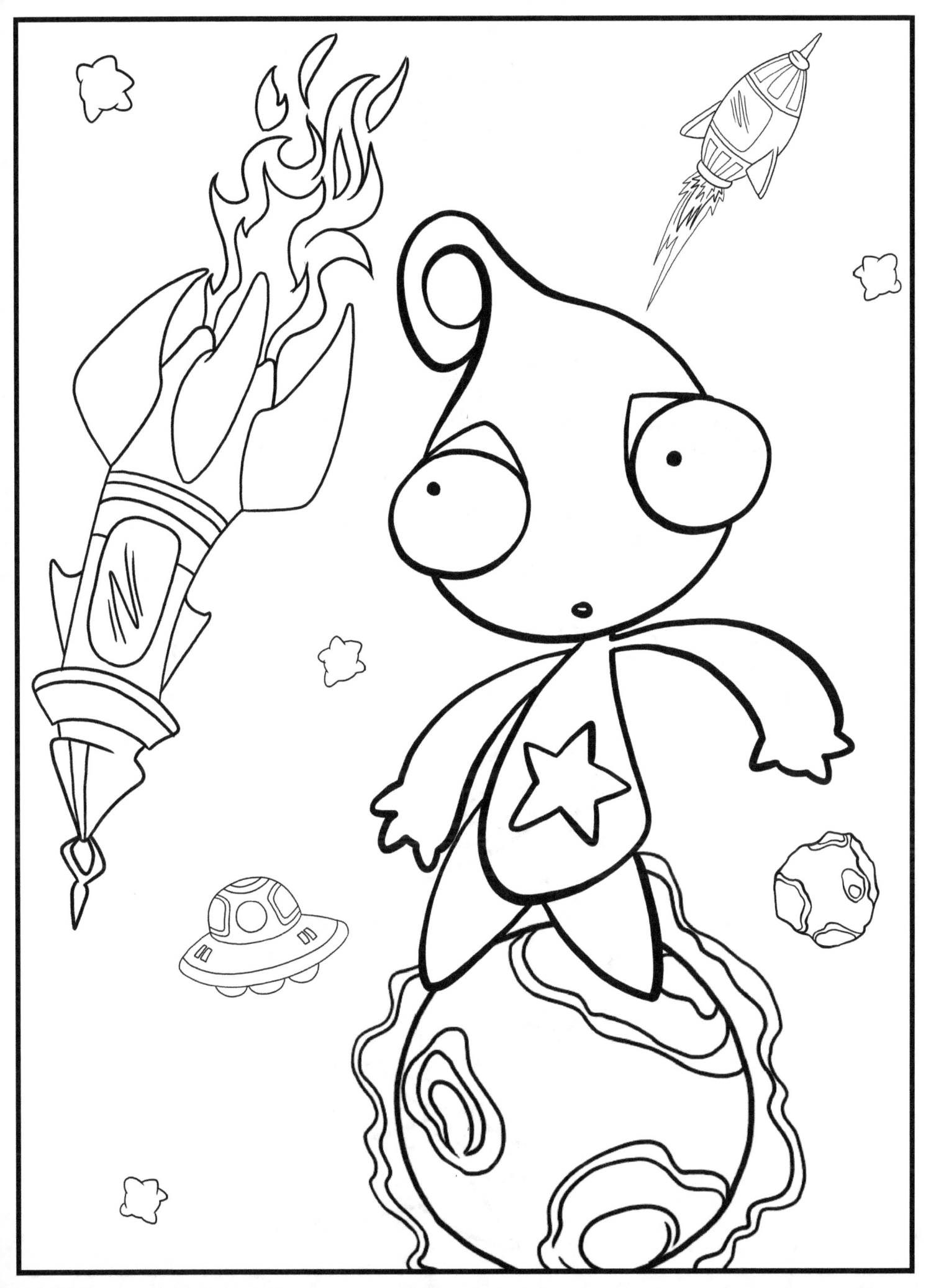

...CHECKING MIRA'S RESILIENCE!

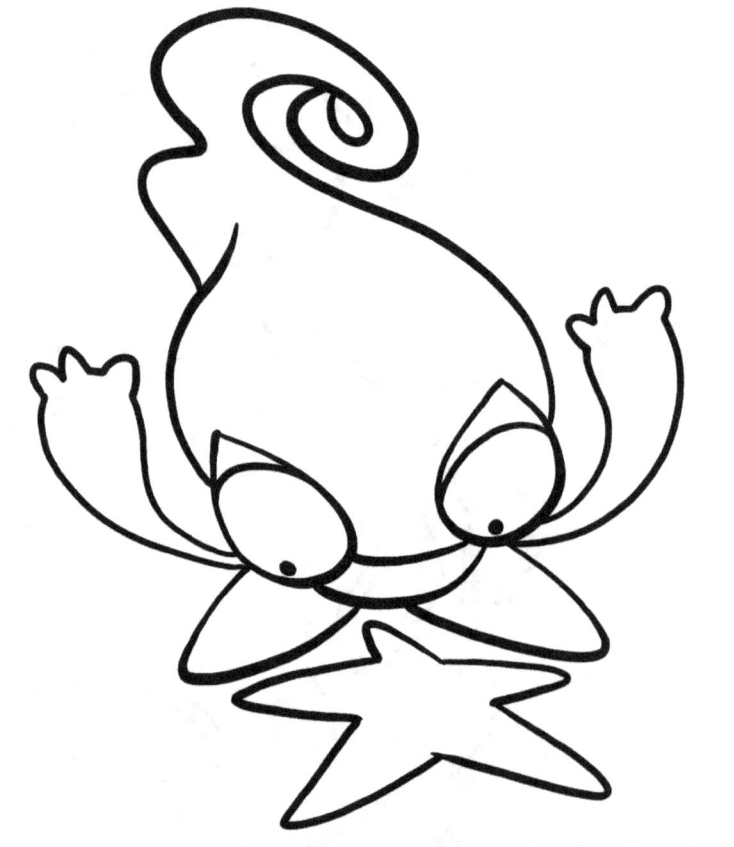

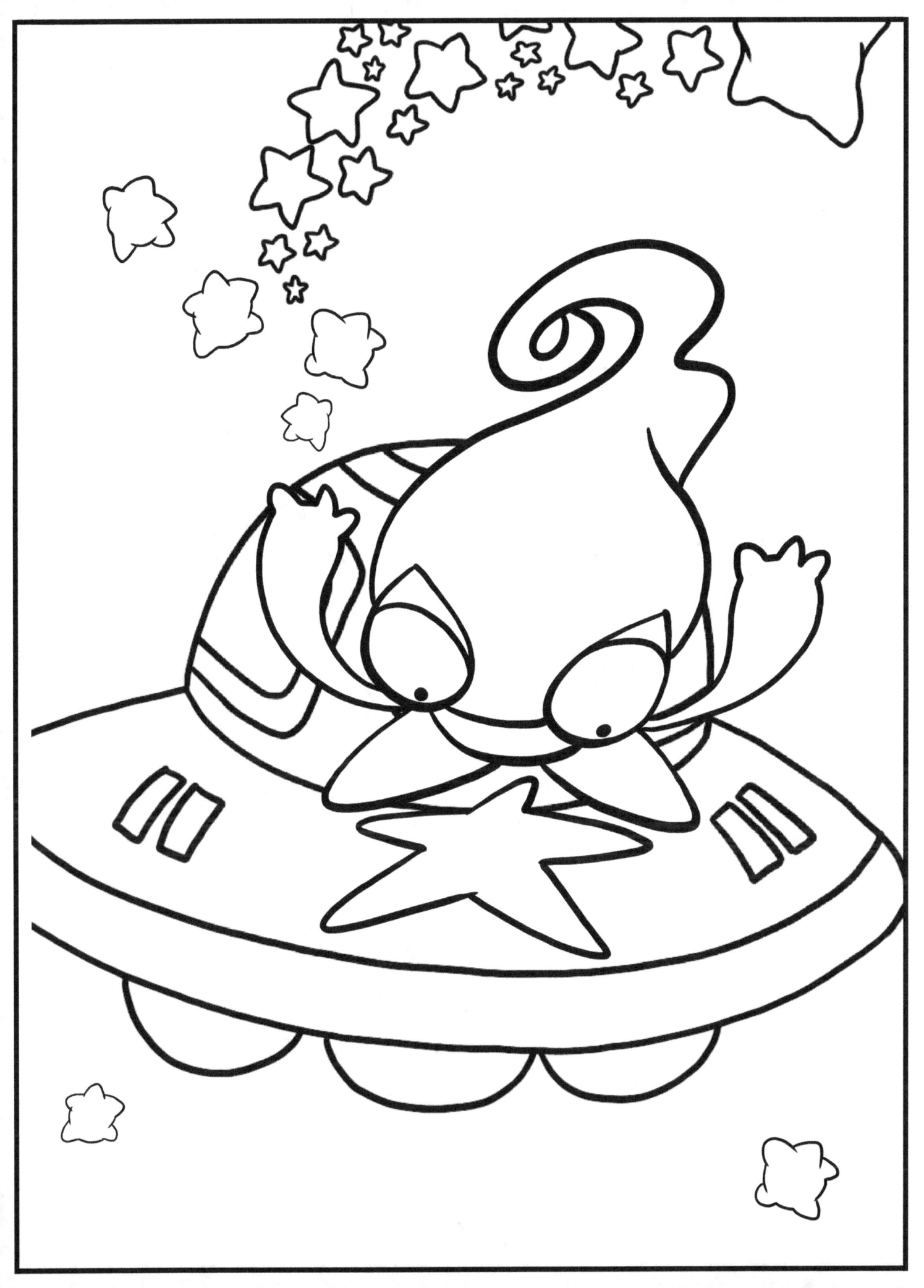

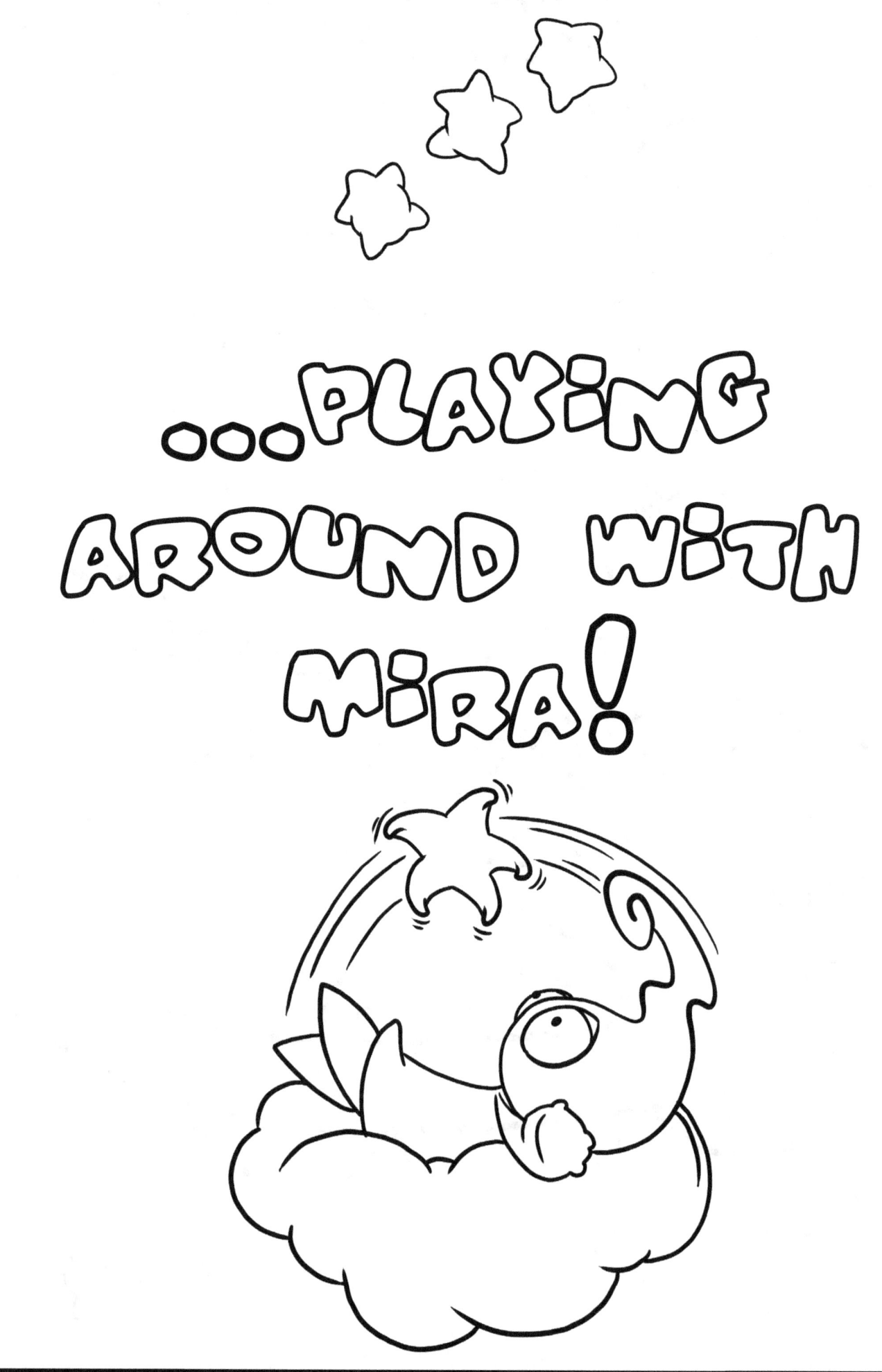

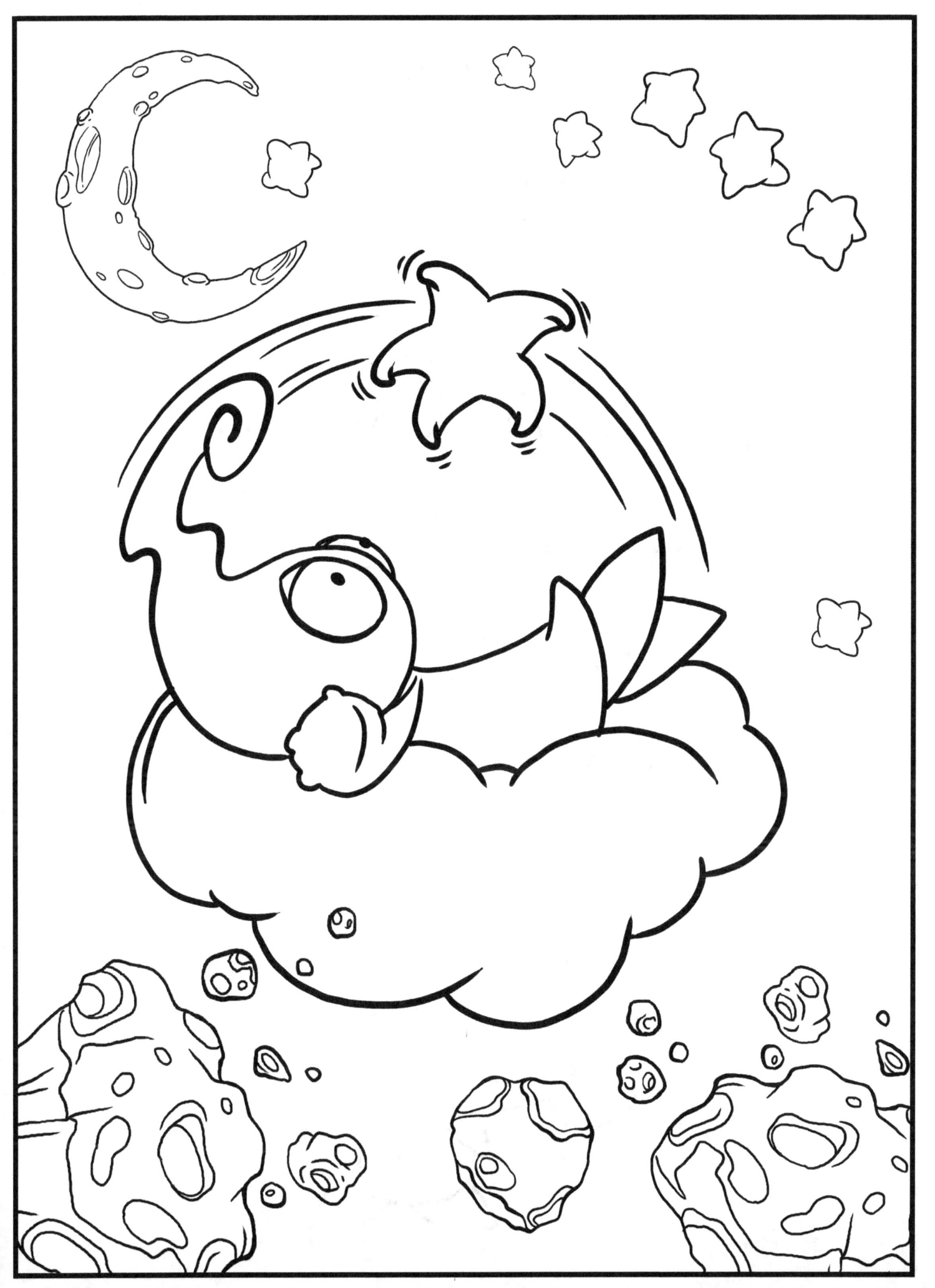

...GAUGING PLANETS' GAPS!

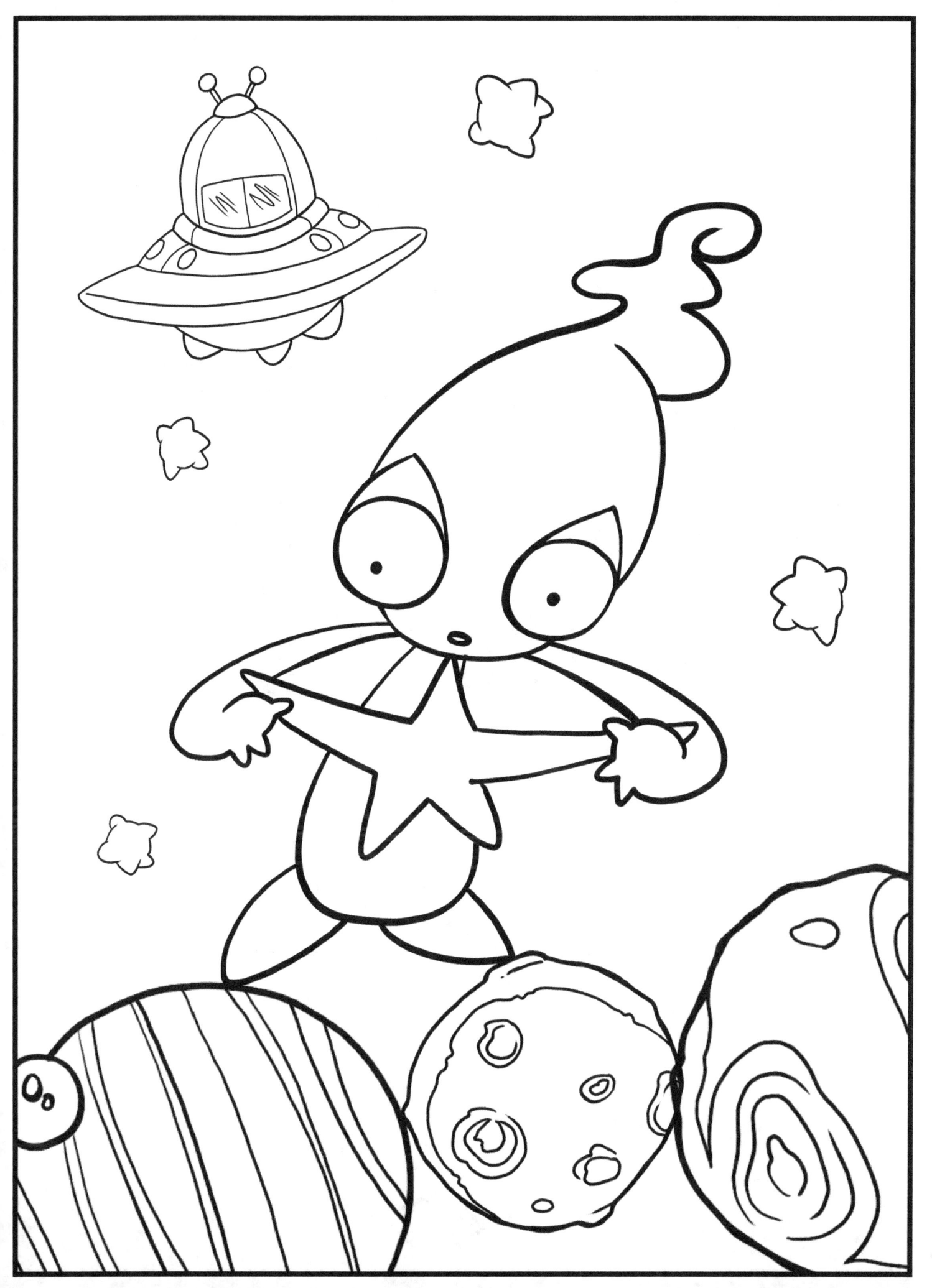

...LOVING EACH OTHER AS BEST FRIENDS!

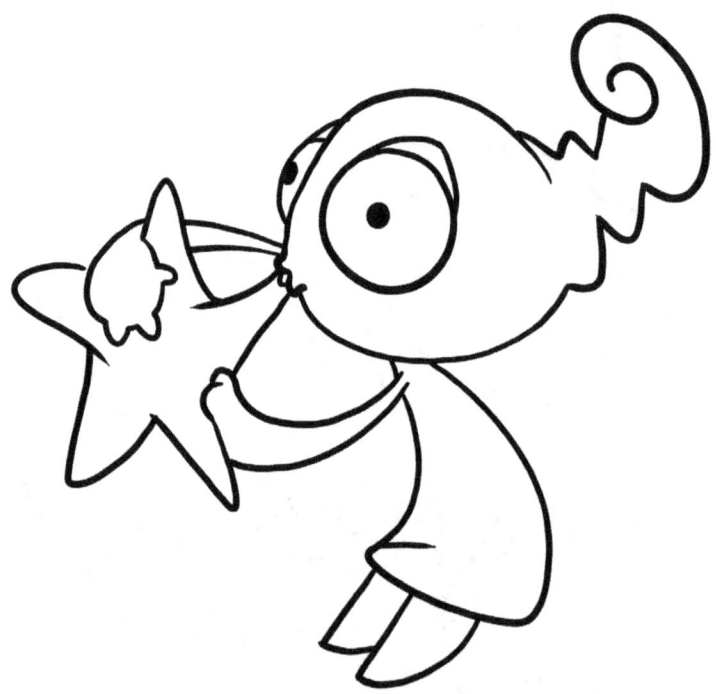

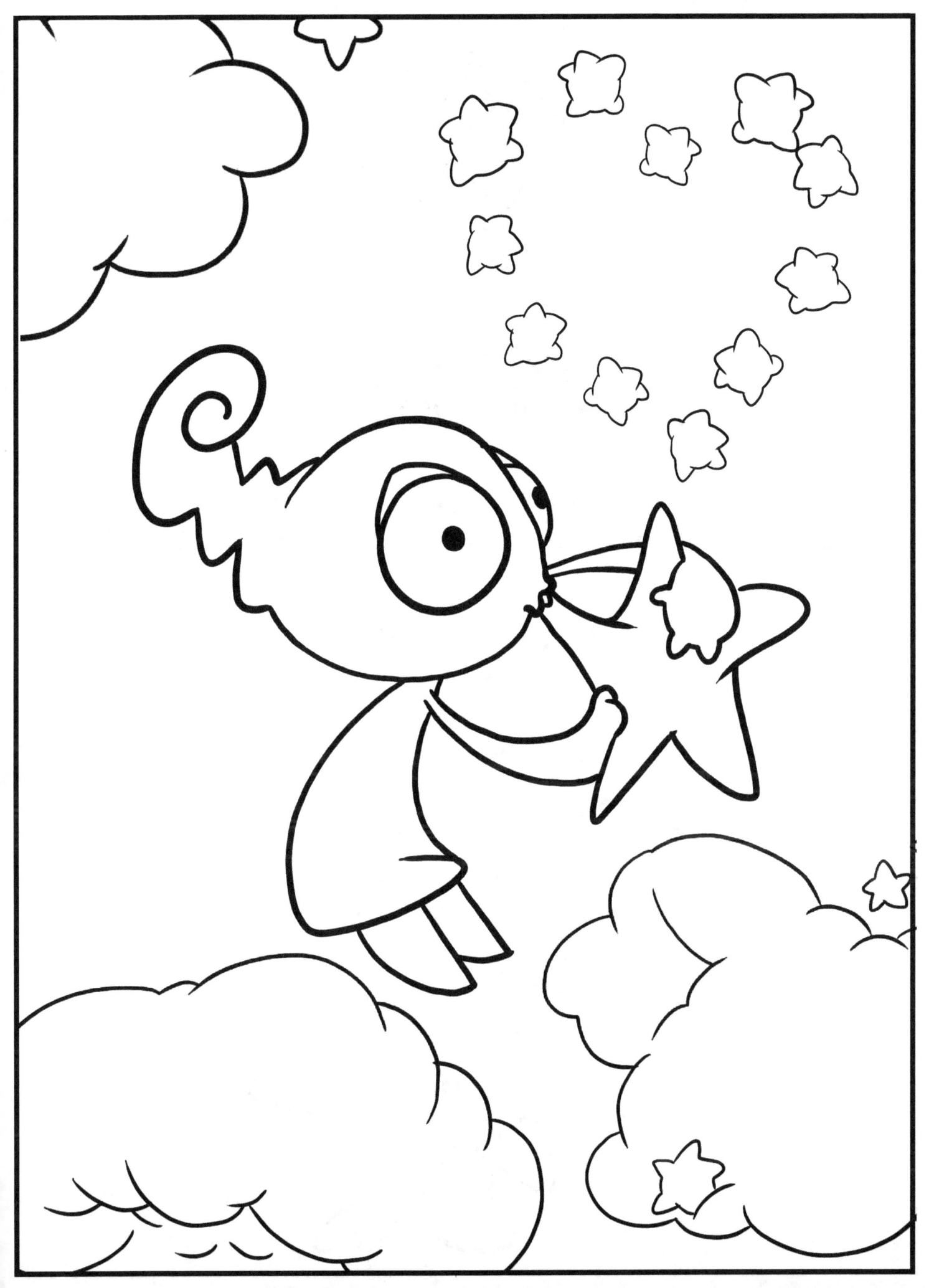

...hitch-hiking in deep space!

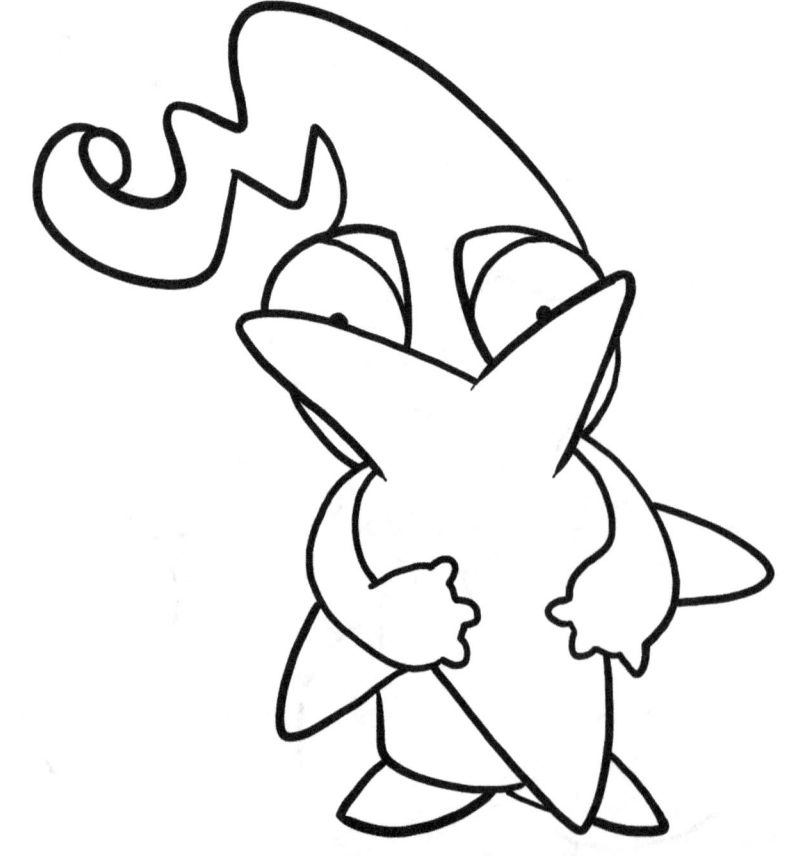

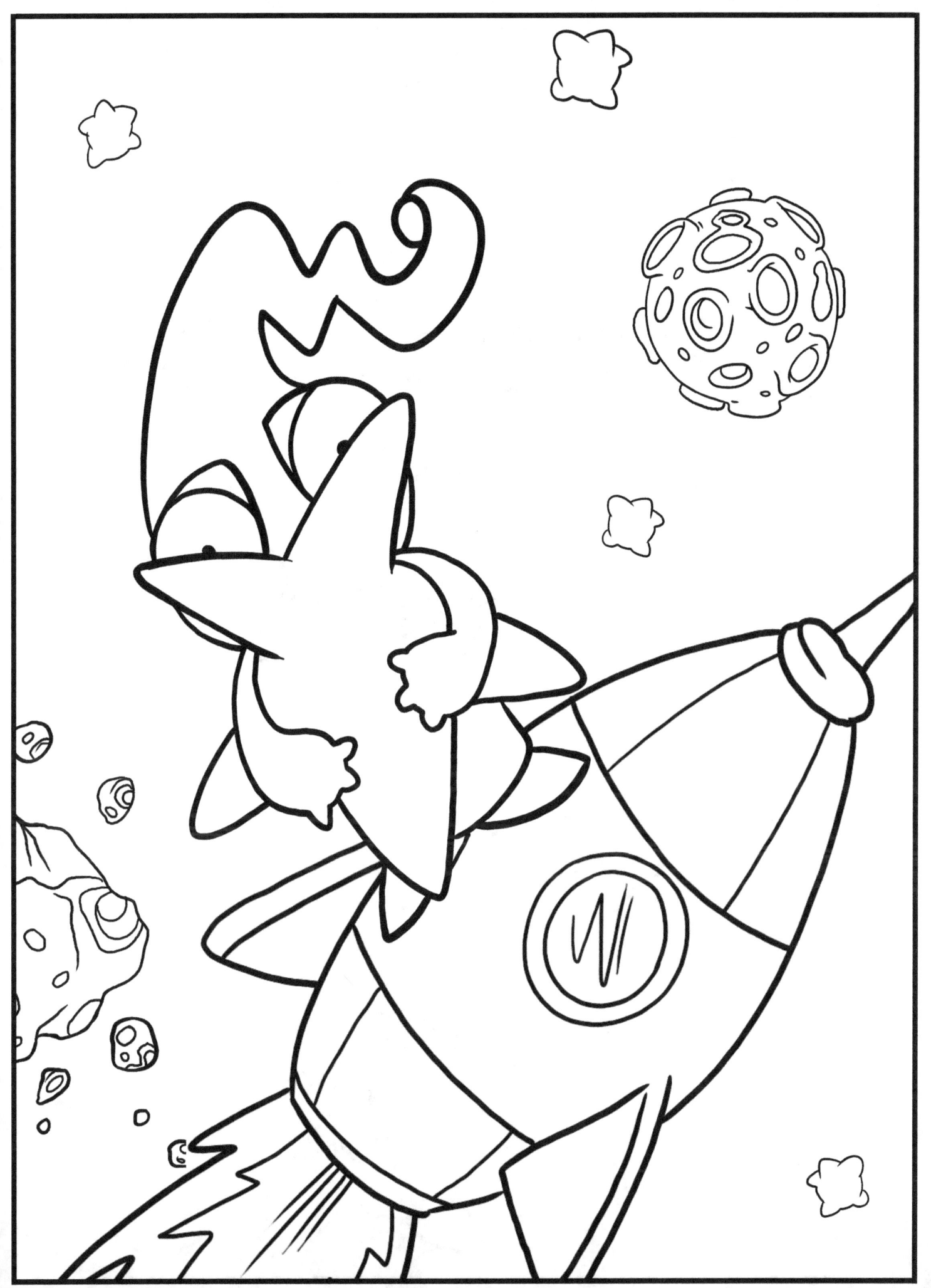

...DANCING ON THE COSMIC RAINBOW!

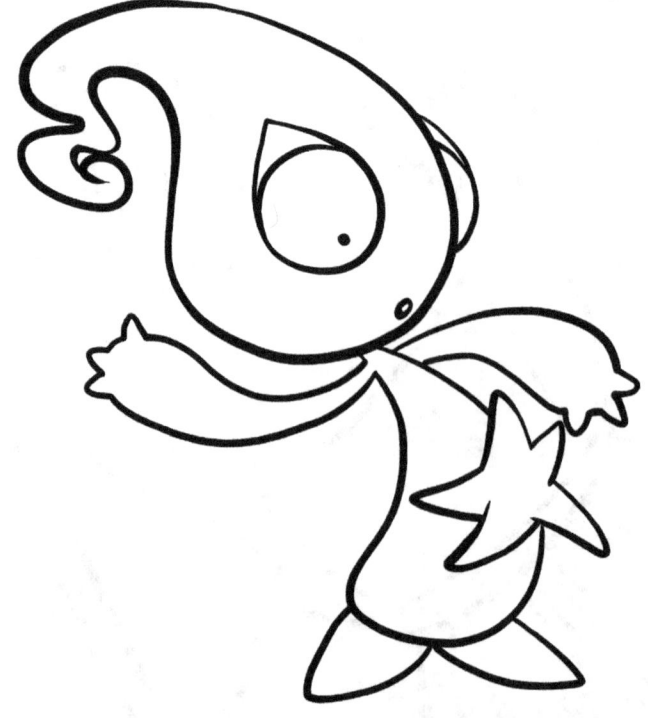

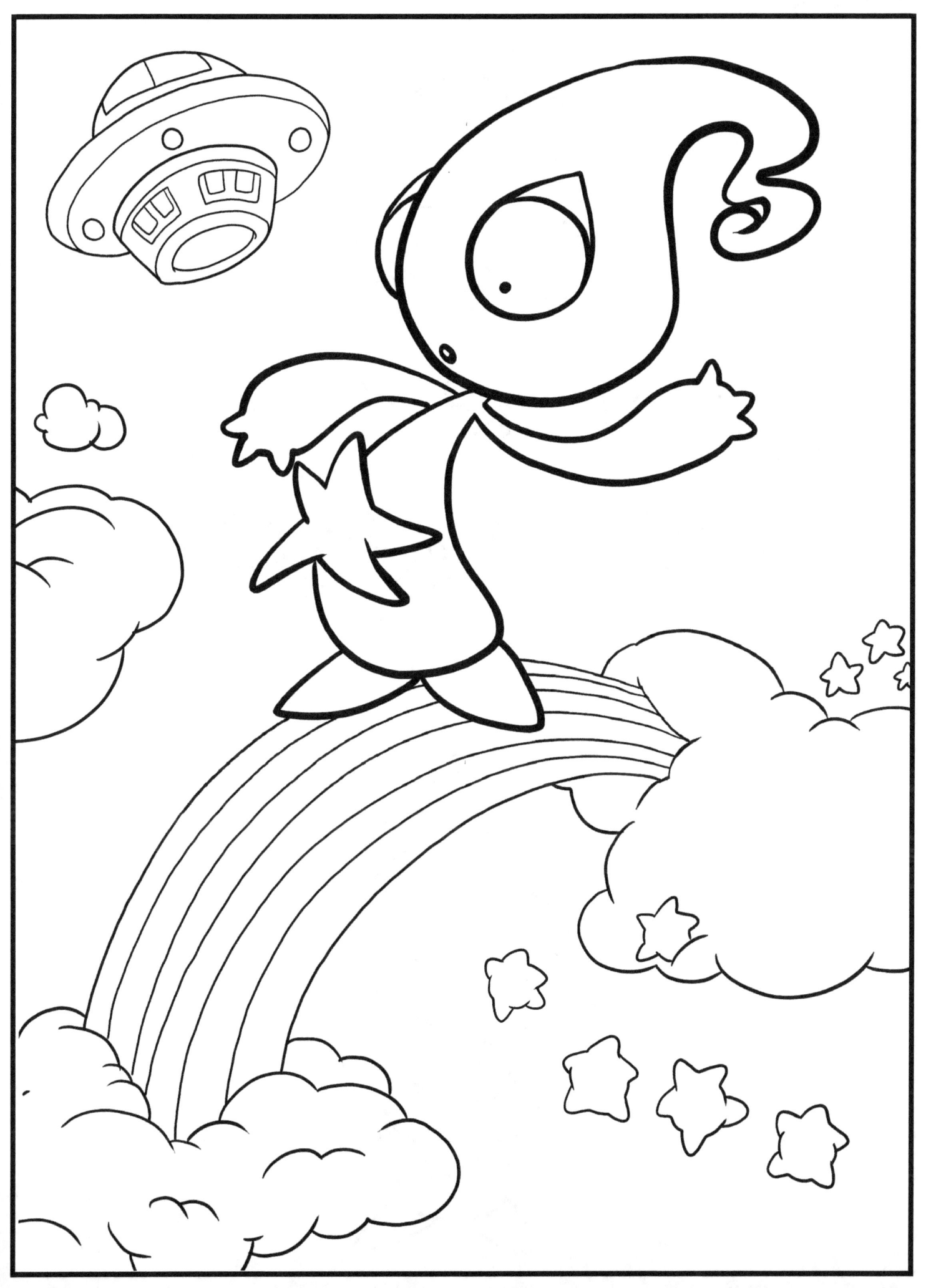

...CLIMBING THE SKY STAIRS!

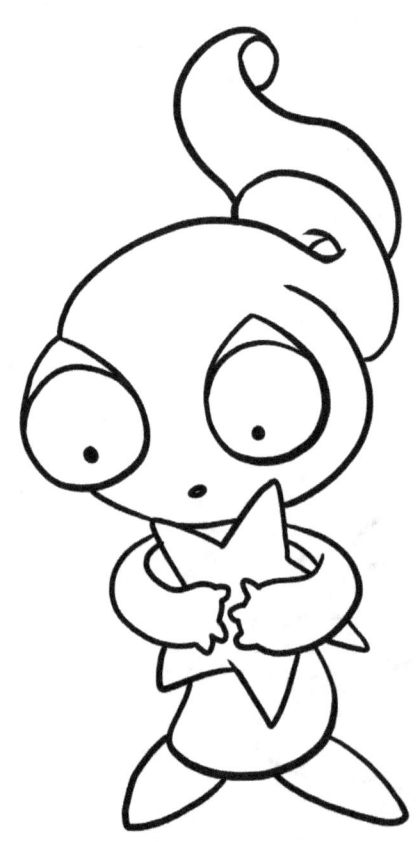

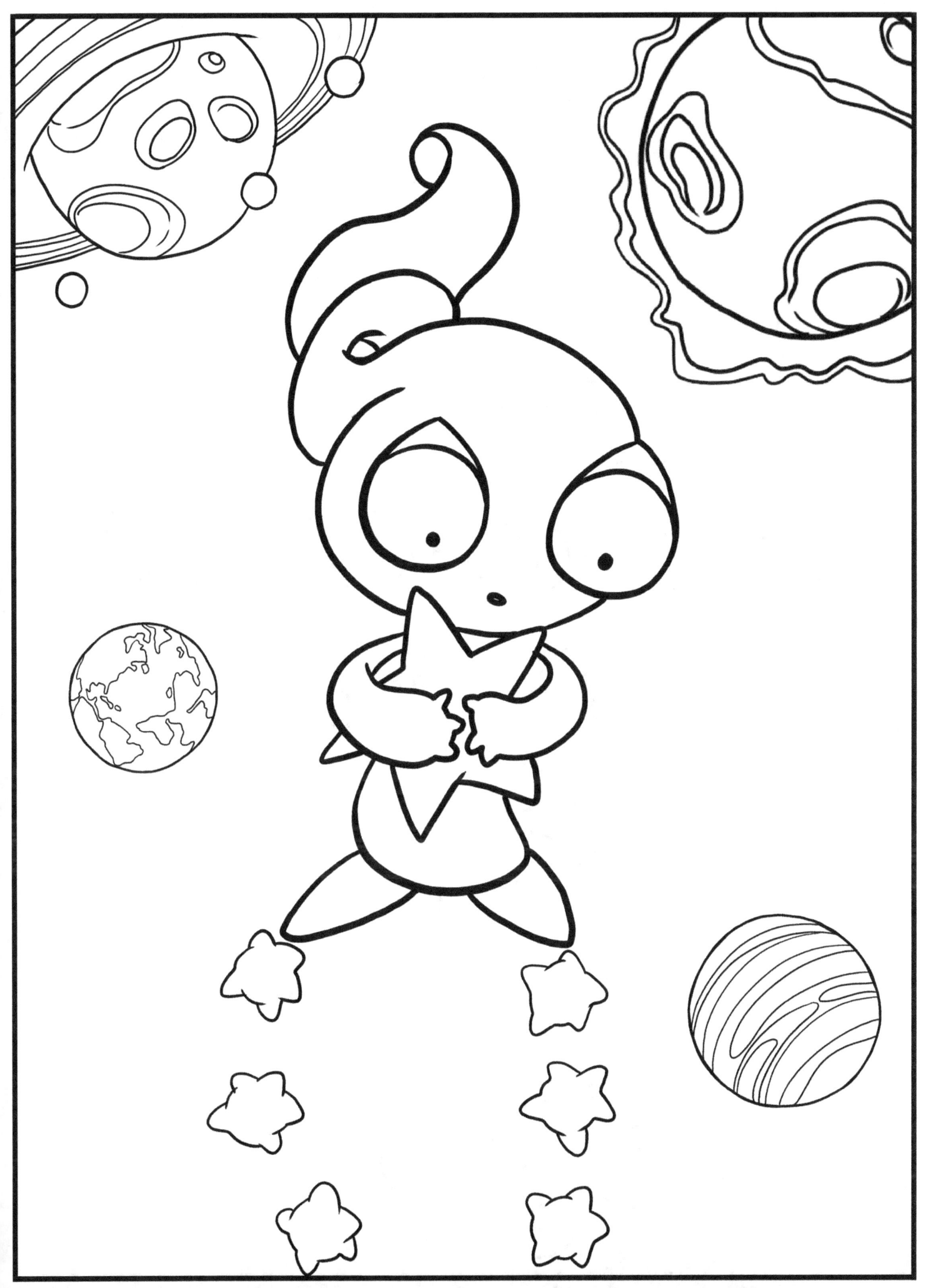

...HELPING MIRA CLIMB THE CLOUD!

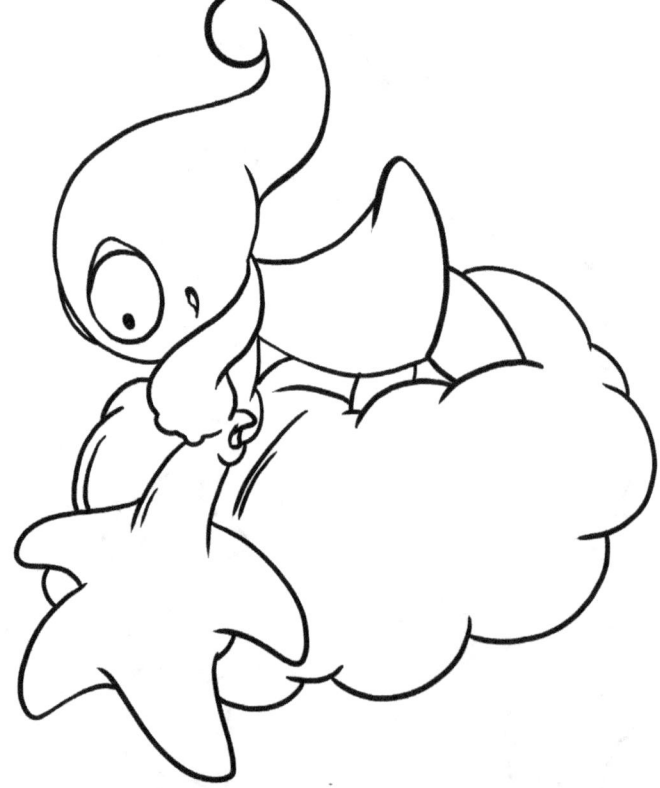

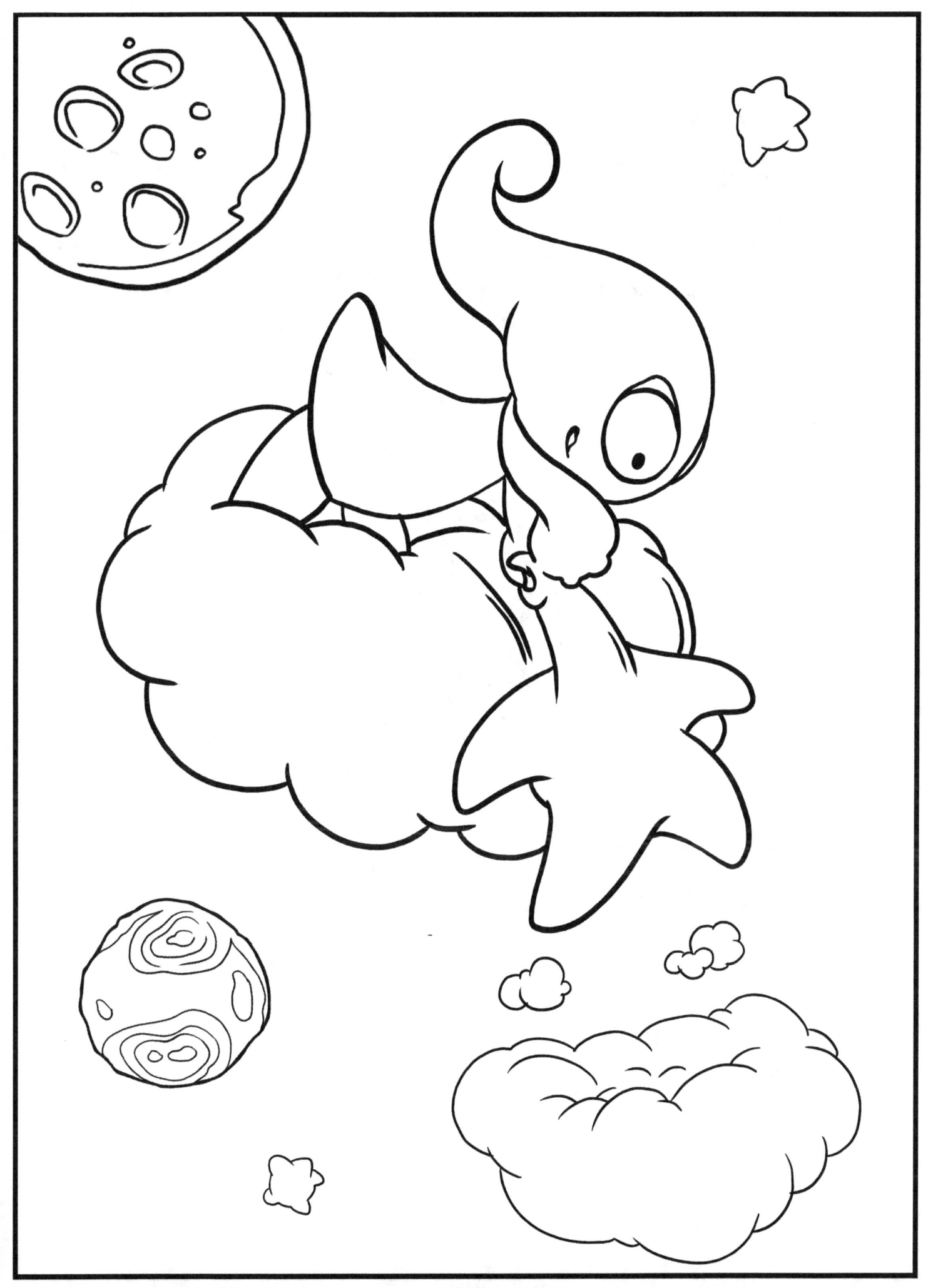

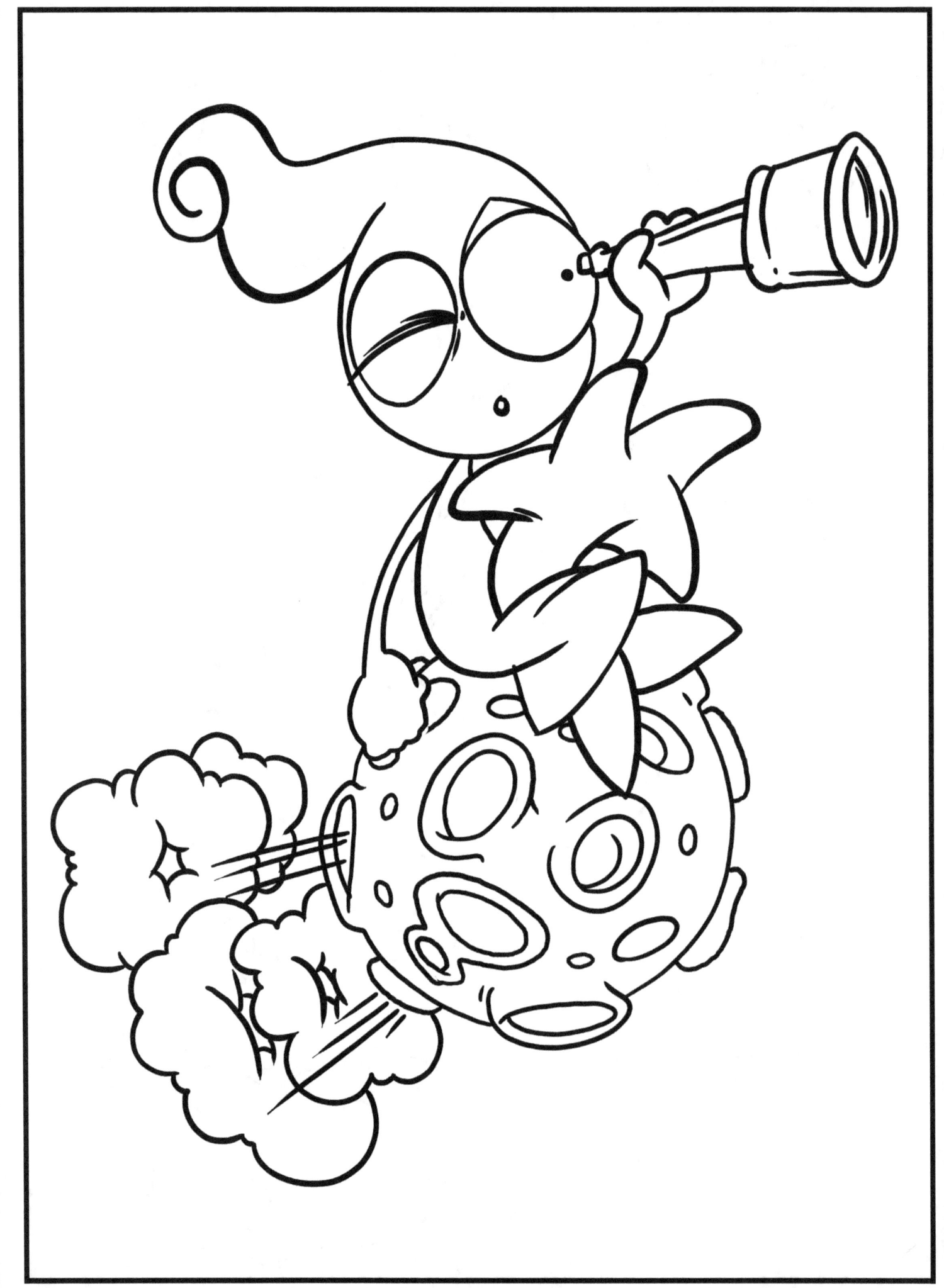

DO-DO PRINTS

I DO, YOU DO, WE LEARN!
DO-DO PRINTS IS DEDICATED TO EDUCATION AND EDUTAINMENT.
IT INCLUDES A VAST RANGE OF PRINTABLE AND ELECTRONIC BOOKS FOR CHILDREN, YOUNG ADULTS, ADULTS AND ELDERS WITH THE AIM TO IMPROVE THEIR COGNITIVE SKILLS AND KNOWLEDGE IN AN ENJOYABLE WAY.
DO-DO PRODUCTS ARE CREATED IN DIFFERENT LANGUAGES IN ORDER TO REACH AS MANY READERS AND POSSIBLE AND PROVIDE A COMPLETE EDUCATIONAL AND AMUSING EXPERIENCE.

DO-DO@BEMYSTUDIO.COM

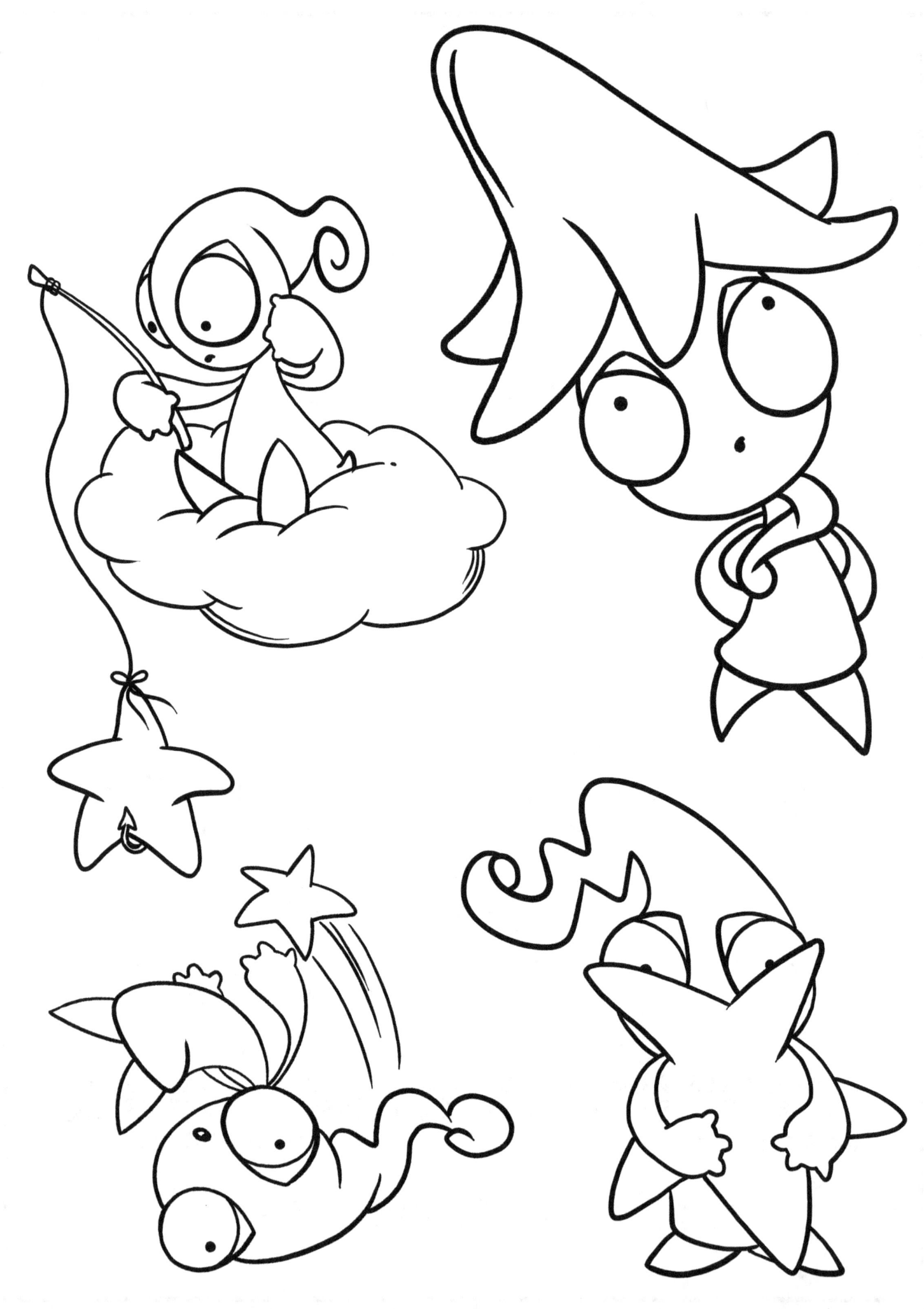

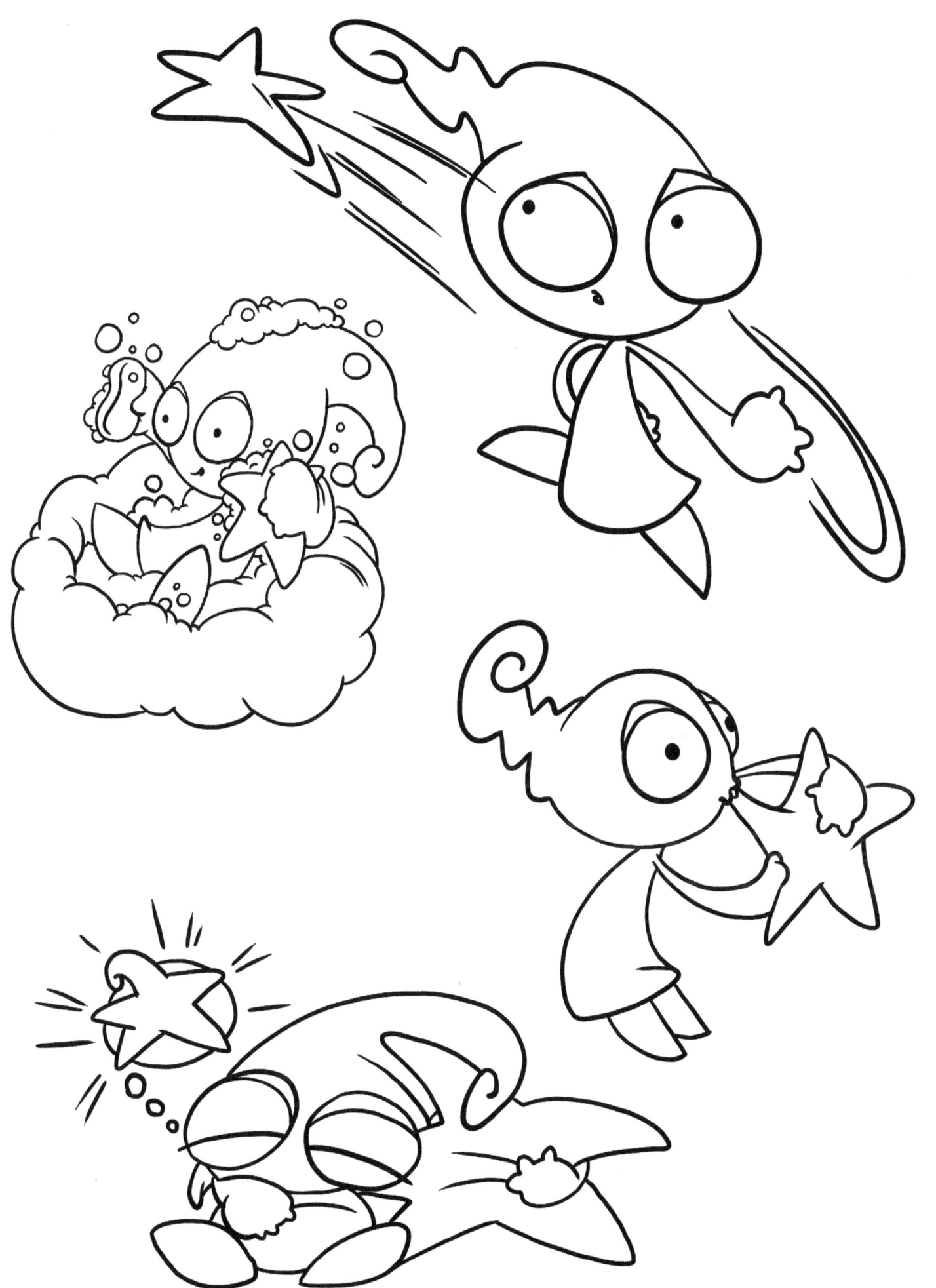

www.ingramcontent.com/pod-product-compliance
Lightning Source LLC
Chambersburg PA
CBHW080945170526
45158CB00008B/2377